50 Art ACTIVITIES

for Your Kindergarten Classroom

Photographs: pp. 4, 8, 9, 25, 43: James Levin; p. 35: John Fortunato; p. 55: Ross Whitaker.
Illustrations: Rita Lascaro; Cover: Mary Thelan; pp. 6-7: Ellen Sasaki.

Copyright © 1997 by Scholastic Inc.
All rights reserved. Published by Scholastic Inc.
Printed in the U.S.A.
ISBN 0-590-32777-1

3 4 5 6 7 8 9 10 02 01 00

Contents

50 Art Activities

Introduction

Art in Kindergarten

Children's art explorations often center on physical experiences such as finger-painting.

Creative Expressions

The wind is gently blowing autumn leaves through the air. In the classroom, childrens' noses are pressed against the window as they try to name all the colors that fill the air. Meanwhile, another group is using an old blanket and some chairs to arrange a suitable theatre for their puppet show. Still other children are experimenting with paints and paper to create wall hangings for the room.

Kindergarten is a time when children actively develop imaginative and flexible ways of thinking. By keeping them exposed to art experiences throughout your classroom, you can help children tap into their own potential for creative expression.

Art Across the Curriculum

Often, art is considered to be an activity separate from curriculum: a time for children simply to explore on their own. But in fact, art provides tremendous possibilities for teaching and learning in every curricular area.

In addition to being a guide for exploring various media, this book is designed to help teachers make the connections between art and language, art and science, art and social studies, and art and math. Through these activities, children will develop an understanding of important concepts. Skills learning and creativity need not be separated; when used in tandem, each enhances the other. Teachers can encourage children's originality and self-expression while they are teaching math or any other subject. With teachers as guides, children feel they are making their own discoveries; through this process, they develop a love of learning to last a lifetime.

This book offers 50 developmentally appropriate art activities for kindergartners. They are organized by content areas: Art: Exploring the Media, Art and Language, Art and Social Studies, Art and Science, and Art and Math.

As you adapt the activities for your children, keep in mind that they are designed to be open-ended and can be combined with children's ongoing explorations across all areas of the curriculum. Use the Art Setup on the following pages as a guide for gathering great materials and equipment to create and enrich your home base for art activities.

Getting the most from the activity plans

The activity plan format is simple and easy to follow. Each plan includes most of the following:

AIM: The purpose of the activity; what children will do and learn.

MATERIALS: Basic art materials and special items to gather. Ingredients for making materials, such as homemade play dough, may also be listed.

IN ADVANCE: This is an occasional heading found in some plans. It often suggests materials to make or to gather before introducing the activity.

WARM-UP: Ways to introduce the activity or underlying theme. Open-ended questions help children think critically and probe topics more deeply.

ACTIVITY: Steps and suggestions for introducing materials, helping children get started, and guiding the activity.

REMEMBER: Social/emotional,cultural, and developmental considerations; tips about ways to relate other skills and concepts to the activity theme; and occasional safety reminders.

OBSERVATIONS: Ideas and strategies for observing children that will help you understand children's individual learning styles as well as help you guide, extend, or evaluate the activity.

BOOKS: Children's books related to the activity or theme.

SPIN-OFFS: Ideas for extending the activity into different curriculum and skills areas.

Colleagues, aides, student teachers, volunteers, and family members can all benefit from fun suggestions for child-centered art activities. So feel free to duplicate and share the plans for your program's use.

ArtSetup

1 Materials that are well-organized and accessible encourage children to explore various media.

2 Examples of artists' work can inspire children while exposing them to different artistic styles.

3 A color wheel introduces children to the many shades and tones of color that they can use in their artwork.

4 Self-portraits encourage language as children express themselves and find out more about each other.

5 A well-supplied painting center is a great place for creative expression.

6 A display of their artwork encourages children to talk about one another's work and inspires them to create their own.

7 Collected recycled materials are terrific for collage and construction.

8 Sketchbooks are a good place for children's drawings because they can see the progression in their own work.

9 Hang paintings on a clothesline to dry. This also acts as a temporary display of children's art.

10 Collage and paper sculpture allow children to explore different textures and practice small-motor skills.

11 Large-scale projects encourage cooperative learning and promote social awareness.

12 Clay is a tactile material that invites children to experiment, making it a wonderful tool for self-expression.

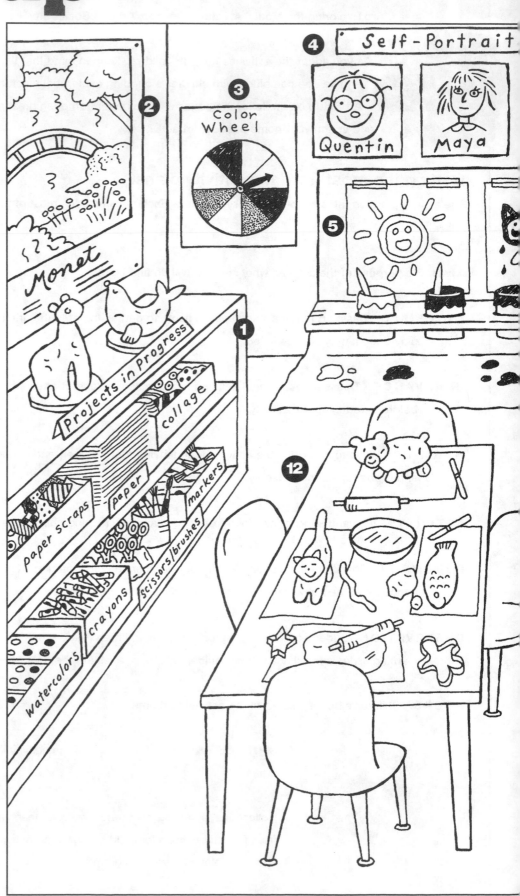

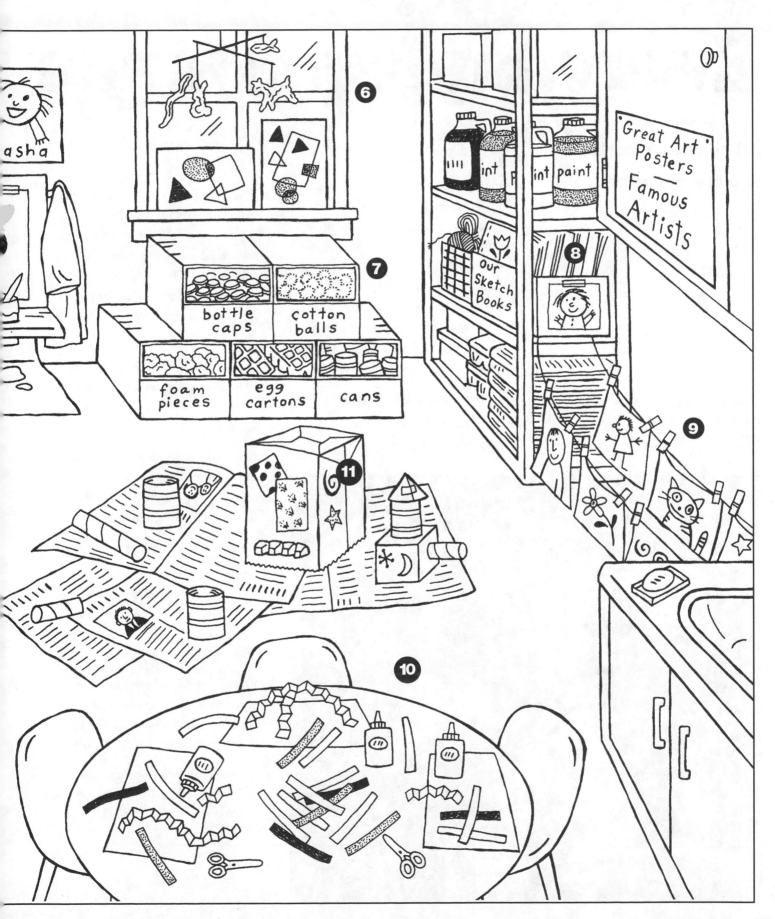

MakingArtan EverydayExperience

Art plays an important role in every area of your classroom.

Children can create their own magical environments for dramatic play.

When children are engaged in creative art experiences, they are building many important skills, such as fine motor and eye-hand coordination, language, creative thinking, and problem solving. The skills children build through artwork help them to learn in every area of the classroom. Paints, crayons, clay, and pastels should not be simply stored away in the "art corner." In this book you will find practical ways to let art bring new life to any learning environment.

Throughout the Day

- Use art activities to enhance dramatic play or block building. Painting large boxes and making signs are especially appealing to children.

- The outdoors is rich with art possibilities. Use giant chalk to draw on sidewalks. Notice the many different and wonderful textures, from tree bark to silky leaves. Chain-link fences provide a great mesh for weaving. Or just set up a quiet area to observe all the wonders and beauties of nature.

- Whenever possible, encourage children to focus on the processes involved in their day-to-day activities rather than just the product.

- Encourage children to think visually during everyday activities. Children can use visual imagination while telling stories, even while setting out snacks!

Around the Room

- Display pictures in the art area of men and women (including those with special needs) involved in creative activities such as art, architecture, and house painting.

- Enhance children's awareness of art. Draw their attention to the pictures in books. Display prints by artists that appeal to children.

- Comment on colors, patterns, shapes, and the use of space in all areas of your classroom.

Activity Plans for

ExploringtheMedia

A balanced art program gives children opportunities to engage in drawing, painting, printmaking, collage, and modeling. When children begin to paint, draw, cut, and mold, they are building motor skills and experiencing the sense of power inherent in controlling the medium and the final outcome. Each artistic medium has its own physical quality; encourage children to notice these differences.

These activities are designed to introduce children to the properties of different materials. Once they are familiar with these properties, invite children to mix media in different combinations. Through this process children's knowledge can grow alongside their creativity.

Enhancing the Skill

■ Encourage children to move from larger to smaller spaces as they become more familiar with the artistic medium. For example, when they use watercolors, invite children to paint with water on sidewalks. Then move inside to a smaller easel.

■ Offer children a wide variety of materials that are appropriate to their various levels of development. Children at this age are beginning to show greater finger and wrist control. By using materials they feel comfortable with, children are likely to feel more control over the outcome of their artwork.

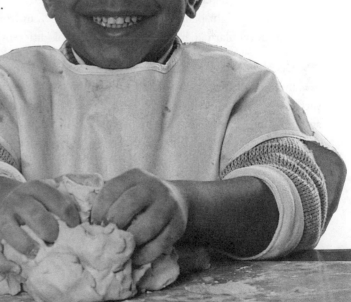

Working with clay is one way for children to enhance their motor skills and spark their creativity.

Have a Painting Party
Painting on paper is just the beginning.

Materials

- different surfaces such as shelving paper, sandpaper, egg cartons, paper bags, adding machine tape, and boxes
- tempera paint of various colors
- paintbrushes in different sizes
- newspaper

Warm-Up

Talk with children about painting. Ask them to describe how it is usually done in the classroom. What might children paint on besides paper? Explain that, together, you will set up the art area so that children can paint on different surfaces.

Activity

1 Talk about possible painting surfaces with children. You might work with surfaces of different sizes, shapes, and textures. Invite children to make predictions. For example, how might paints or sandpaper feel different from painting on regular paper? Would the paint look different?

2 Decide together which surfaces to use. Remind children that not all surfaces are suitable for painting. Discuss surfaces that would be inappropriate, such as walls, floors, and furniture. Together, create guidelines for the painting party that everyone can agree upon. Set out the painting surfaces, using newspaper to cover floors and tables.

3 Once the area is set up, help children choose their paint surfaces. Encourage them to paint and experiment with the available materials. When they finish with one surface, invite children to switch painting surfaces and continue their explorations. Encourage children to talk about the different textures.

4 Later, discuss with children how the paintings they created can be used. For example, some flat paintings could be mounted in a display, and painted boxes could become a creature or vehicle for dramatic play. Some children may want to combine their painted objects into one special work of art.

Observations

- How do children adapt to painting on different surfaces? What do they notice about the texture and appearance of their work?

Books

Here are some fun books about painting to help inspire children's creativity.
- *Begin at the Beginning* by Amy Schwartz (Harper & Row)
- *Francie's Paper Puppy* by Achim Broger and Michelle Sambin (Picture Book Studio)
- *The Painted Tale* by Kate Canning (Barron's Educational Books)

SPIN-OFFS

- Try out unusual materials for paint application. Put out things like marbles, yarn, plastic-foam pieces, dish mops, tree branches, and sponges. Each material will inspire children to try out different ways to apply paint.
- Another way to explore paint is by using different applicators. Try using rollers, sponges, popsicle sticks, or feathers instead of brushes.

Wind-Powered Painting

Mural-making with a new twist.

Materials

- large sheet of butcher paper or mural paper
- tempera paint thinned with water
- Ping-Pong or small plastic-foam balls
- shallow pans
- newspaper
- straws

Warm-Up

Gather children for a discussion about wind. Talk about how wind is moving air and how it can move things like trees or flowers. Then discuss different ways that people can make air move, like blowing out with their mouths or waving their arms. Invite children to demonstrate.

Activity

1 Clear an area of the floor and cover with newspaper. Place mural paper in the center and invite children to sit around it. You may want to have children work in small groups. Pour thinned paint into the shallow pans, and set them on the newspaper along with the Ping-Pong balls.

2 Ask children to dip the Ping-Pong balls in paint, and then challenge them to move the balls without using their hands. Encourage them to try blowing the balls but be flexible about other ideas they come up with. For example, they might try clapping in front of the ball or blowing through a straw. Some may even blow on one ball

as a group to see how far it will go across the paper. Talk about the patterns the balls leave on the paper.

3 Once children get the hang of wind painting, encourage them to set specific challenges or goals they want to achieve. For example, a child might decide to blow a ball a certain distance or to blow balls in straight lines to create stripes. Help children problem-solve ways to meet their goals, and encourage them to talk with each other about their ideas.

4 As children finish, ask them to talk about what they wanted to achieve in their wind painting and how they think it worked out. You may want to write their thoughts on chart paper and display them with the mural to encourage further discussion.

Observations

- How do children work cooperatively to achieve desired effects? Are they able to share problem-solving strategies and resolve conflicts on their own?

Books

Share these books about the wind.
- *Curious George Flies a Kite* by Margaret Rey (Houghton Mifflin)
- *Jonathon Plays With the Wind* by Kathryn Galleant (Coward-McCann)
- *The Red Balloon* by Albert Lamorisse (Doubleday)

SPIN-OFFS

- Drop small spoonfuls of paint on finger-paint paper or other nonabsorbent paper. Let children use straws to blow the paint directly on the paper. The results are more fanlike and delicate than those achieved with Ping-Pong balls. Children can also experiment by blowing on the paint without using a straw. Can they make the paint move without the straw? Are the results different?

Bubble Prints

Blowing colored bubbles makes interesting art.

Materials

- dish soap
- food coloring
- drawing paper
- 2 plastic cups per child
- water in basins or in a water table
- 1 plastic straw per child (plus extras)
- measuring cup

In Advance

Cover a table with a plastic sheet or bags to keep it clean. Pour about two inches of water into your water table or basins. Add dish soap a little at a time until you have just enough for bubbles.

Warm-Up

Offer each child a straw, and encourage them to practice blowing out. Then ask them to put one hand a few inches from the open end of their straws before blowing. Ask if they can feel their breath, or air, coming out. Ask children if they have ever blown bubbles using a wand. How did it work?

Activity

1 Gather with a small group at your covered table. Offer each child one or two paper cups filled about halfway with the soap-and-water mixture. Then let each child choose a food coloring, and help everyone use it to tint their bubble mixture.

2 Ask children to practice blowing out through their straws one more time. Then invite them to put their straws in their cups and blow to make bubbles.

3 When children are ready, invite them to gently lay a piece of paper over the top of the cups and blow. Lift the paper to reveal the bubble print that remains.

4 Invite children to make many different bubble prints. Encourage them to experiment with different colors or blowing harder or softer.

Remember

- Children may get wet during this activity. Be prepared by wearing plastic smocks and rolling up sleeves.

Observations

- Do children talk about how the prints get on the paper? Are they able to recognize their own roles in the process and experiment?

Books

Here are some books about the air to share with children.
- *The Ball That Wouldn't Bounce* by Mel Cebulash (Scholastic)
- *Gilberto and the Wind* by Marie H. Ets (Viking Penguin)
- *Matthew Blows Bubbles* by N. M. Falk (McGraw-Hill)

SPIN-OFFS

- Blow bubbles outdoors on a windy day. Whether indoors or out, put on instrumental music. Then encourage children to move their bodies the way the bubbles move. You can also narrate a story about a bubble that glides through the air or is blown by the wind.

Drop Painting

Paint drops can work like colorful raindrops.

Materials

- chart paper
- large paintbrushes
- large sheet of white mural paper
- primary-colored tempera paint, thinned with water
- newspaper
- masking tape

Warm-Up

A rainy day is an ideal time to introduce this activity. Ask children what happens when something is left out in the rain. When it gets wet, how does it change? What would happen to a painting if you left it out in the rain? Record children's ideas on chart paper. If it's raining outside, experiment with scrap paper that has dried paint on it. Let children compare the results with their predictions.

Activity

1 Now invite children to make their own rain with paint. Ask them to help tape newspaper on an open area of the floor. Then tape a large section of white mural paper on top of the newspaper, and place jars of thinned tempera paint around the mural paper. Gather children around the edge of the paper, and invite them to dip their brushes into the paint.

2 Invite children to let the paint fall onto the paper in drops to create a spattering effect. Observe what happens when the paint drops hit the paper. Talk about the changes, if any, in the shape, texture, and even color of the drops.

3 Invite children to try different colors, and talk about what happens when the drops splash together. Challenge them to try different ways of making drops, such as using different-sized brushes or dripping the paint from varying heights.

4 As they work, record children's comments to display along with the completed mural. Ask the group to decide on a title when it is done.

Remember

- While children may discover that flicking the paintbrush will make a terrific paint effect, the process can be messy. You may wish to ask children to help you set rules and guidelines ahead of time so that paint drops do not end up on unintended places.

Observations

- How do children describe the paint drops? What comparisons with rain do they make?

Books

Share these rainy-day books with your class.
- *Plink-Plink* by E. Kessler (Doubleday)
- *Rain Rain River* by Uri Shulevitz (Farrar, Straus & Giroux)
- *The Storm Book* by Charlotte Zolotow (Harper)
- *Umbrella* by Taro Yashima (Viking Penguin)

SPIN-OFFS

- To try another dripping technique, attach a sheet of paper to the easel. Then rip pieces of streamers and lightly glue them to the top. Invite children to spray water on the streamers with a spray bottle. The dye will run, creating an interesting, rainlike effect.

Personalized Stamps

It's easy to make your mark with colorful clay.

Materials

- smocks
- paintbrushes
- 2 pie tins
- plastic mats
- pencils
- construction or drawing paper
- printing stamps and ink pads
- modeling clay
- tempera paints
- paper towels

In Advance

Ask children, friends, and colleagues to bring in printing stamps and ink pads to share.

Warm-Up

Bring your collection of printing stamps to group time, and discuss how they are used. Invite children to show and talk about stamps they brought in. Encourage them to ask questions of one another and discuss the stamps together. Then set out the printing materials for children to use independently.

Activity

1 Work in small groups at your art table. Offer each child a smock, a ball of clay, a plastic mat, and a pencil. Encourage children to explore the texture of the clay. Then suggest that they try using the materials to make their own printing stamps.

2 Let children experiment with ways to make stamps. One way is to roll clay into a ball and press one half of the ball flat, leaving the rest rounded for a handle. They can use the pencils to carve designs, characters, or letters into the flat side of the clay.

3 Help children to apply a small amount of paint to their stamps with a paintbrush or to press their stamps into a thin layer of paint in a pie tin. Then they can blot the paint-covered stamps on the paper towel before making a print.

4 Encourage children to try using their personalized stamps to make wrapping paper, border designs for bulletin boards, or decorative envelopes and letters to send home to families.

Observations

- Modeling clay has a very distinct texture. How do children adapt to the texture of modeling clay? How do they describe it?

Books

These books offer a look at other printing techniques for children to try.
- *Let's Visit a Printing Plant* by Catherine O'Neill (Troll Associates)
- *Printing* by Hilary Devonshire (Watts)
- *Printing and Patterns* by Tony Hart (Trafalgar Square)

SPIN-OFFS

- Ask children to work in pairs or small groups, alternating each other's prints on paper to create beautiful patterns. Children can use the patterns in the ways suggested above, or they can make up their own uses. They might also like to make a "welcome" sign for the classroom door, using their stamps in lieu of signatures.

Coiled Pottery
Turn clay snakes into beautiful pottery.

Materials

- potter's clay
- smocks
- an example of coiled-clay pottery (see Warm-Up)
- spray bottle filled with water
- tempera paint and brushes
- cardboard
- plastic mats
- pencils or plastic knives (optional)

Warm-Up

Coiled pottery is made by rolling out pieces of clay into "snakes" and coiling them upwards. Bring in an example or make a simple pot to show to children. Discuss how it could be used and how it might have been made. Pass the pottery around so that children can feel its texture.

Activity

1 Provide a mat, a smock, and a ball of clay for each child. Allow time for children to experiment with squeezing, pulling, pressing, and rolling the ball.

2 Now encourage children to roll small pieces of clay to make snake shapes. Invite children to use the coils any way they choose to make designs, pots, coiled disks, or other items. (As children work, spray their hands with a little bit of water occasionally to keep them moist, but avoid getting the clay too wet.)

3 Encourage children to make a base, either by coiling clay or simply flattening a piece into the shape that they want. Then they can lay the coils atop one another to form the sides of the object. Encourage children to use the coiling technique to make pots in their own styles. They might like to carve designs on the coils, using pencils, plastic knives, or other objects.

4 Ask children to place their finished creations on cardboard to dry over night. The next day, children can use tempera to paint their clay pieces.

Remember

- Some children may invent a new creation rather than construct a pot. Encourage them to describe their creations and share ideas with each other.

Observations

- How do children respond to the feel of clay? How does time for open exploration help them generate ideas of things to make?

Books

Look for these books about working with clay and pottery.
- *Clay* by Mike Roussel (Rourke Corp.)
- *The Magic Vase* by Fiona French (Oxford University Press)
- *A Potter* by Douglas Florian (Greenwillow Books)

SPIN-OFFS

- Set up a clay station in your classroom for several days or longer so that children can further explore this medium. To inspire children, bring in examples or photos of other objects made from clay, including practical and decorative objects and sculpture.

Beads, Beads, Beads
Roll them, paint them, string them, sort them!

Materials

- paper or cardboard
- potter's clay
- tempera paints
- pencils
- clay, wooden, and plastic beads in different sizes, shapes, and colors
- mural paper or paper grocery bags
- small dowels of various diameters
- spray bottle filled with water
- plastic straws and toothpicks

In Advance

Collect a variety of beads and put them in a shallow box with a lid. Then set them out in your manipulatives area for children to play with independently.

Warm-Up

After children have had time to explore the beads, bring them to group time. Pass a few around, and invite children to talk about how they might have been made and what materials might have been used. Then point out a few clay beads and discuss what they are made of.

Activity

1 Cover your table with mural paper or grocery bags, and spread your bead collection in the middle. Offer each child a small ball of clay. Invite children to roll, push, and pull the clay.

2 Encourage children to use the clay to make their own beads. Note that the beads on the table don't have to be copied but are meant to help inspire children's own ideas. As they work, ask children to describe what they are doing and how the clay feels in their hands. (Use the spray bottles to keep their hands moist.)

3 When children are ready to make holes in their beads, put out the pencils, straws, toothpicks, and dowels. Invite them to experiment with the different hole-punching materials.

4 Help children place their beads on pieces of paper cardboard to dry. Another day, provide tempera paints and invite children to color their beads. Talk about how children will use their beads. They may want to make jewelry, use them for counting and sorting, or invent a new use for them.

Observations

- What types of shapes are the children's beads? Do they talk about their creative process as they work?

Books

Add these related books to your library.
- *All Shapes and Sizes* by Shirley Hughes (Lothrop, Lee, & Shepard)
- *Ten Black Dots* by Donald Crews (Greenwillow Books)
- *The Touch Book* by Jane Moncure (Children's Press)

SPIN-OFFS

- Cut yarn into 12-inch pieces. Tape one end of each piece and knot the other. Offer children the yarn, along with some beads for stringing and patterning. Children can also string beads onto pipe cleaners to make bracelets.
- Children can also use clay to create buttons of different sizes, shapes, and colors. The buttons can be used for jewelry-making or math manipulatives.

Sun Clay

This modeling material won't crumble in the sun.

Materials

- marker
- hot plate or stove
- large mixing spoons
- 1 cup cornstarch
- plastic bag
- plastic trays or paper plates
- saucepan
- mixing bowl
- measuring cup
- 2 cups salt
- water

Warm-Up

Try this activity after children have had experience with different types of modeling materials, such as plasticine, clay, and play dough. Explain that you are going to make another kind of modeling dough called sun clay. Ask children to guess why it has this name.

Activity

1 Gather a small group of children to make the sun clay. Since this recipe involves cooking, review safety rules carefully before you begin. Then put 2 cups of salt and 2/3 cup of water into a saucepan and stir. Cook over medium heat for four to five minutes, stirring, until the salt dissolves. If possible, let children look into the pot from a safe distance and talk about what happens to the salt. Remove from heat.

2 In the bowl, slowly add 1/2 cup water to 1 cup cornstarch. Stir until smooth, stopping periodically to let children touch the mixture and talk about the changing consistency. Then add the starch mixture to the saltwater solution, return to low heat, and cook again until smooth, stirring frequently. Store the finished mixture in a sealed plastic bag.

3 Provide children with plastic trays or paper plates and a piece of cooled sun clay to model. Let them model or shape it any way they wish. When they finish, put the sculptures in the sun to dry. Ask them to predict how long drying will take.

4 Later, talk about children's experiences with the sun clay. How does it compare to other modeling materials? One advantage of sun clay — and the reason for its name — is that the sculptures won't crumble easily when they've dried in the sun.

Observations

- What similarities and differences did children find between sun clay and other modeling materials?

Books

Share and enjoy these bright sunny-day books.
- *The Sun* by Michael George (Child's World)
- *The Sun Is Always Shining Somewhere* by Allan Fowler (Children's Press)
- *The Sun's Day* by Mordicai Gerstein (HarperCollins)
- *When the Sun Rose* by Barbara Berger (Putnam)

SPIN-OFFS

- For another kind of modeling, offer children frozen bread dough or pretzel dough that you've thawed out ahead of time. Let children model it any way they like, then place the dough forms on a cookie sheet. Cook according to package directions. Let cool, and then enjoy your edible sculptures!

Colorful Sand

Make colored sand and shake a design.

Materials

- spoons
- funnels
- glue
- fine white sand (available at art supply stores)
- large white construction and mural paper
- 8 small plastic containers with lids
- a hammer and nail (for teacher use)
- food coloring in 3–4 colors
- 1 foil tray for each food color
- 1 hard plastic tray per child

In Advance

Take the lids from four of your eight plastic containers, and, using a nail, poke about four or five holes in each.

Warm-Up

Make colored sand together. First, put out the plastic containers *without* lid holes and ask children to use their hands, spoons, and funnels to fill the containers about half-full with sand. Then help them squeeze a few drops of food coloring in each. Now ask children to put the lid on and shake the containers to mix thoroughly. Pour each container into a separate tray and let dry overnight.

Activity

1 Provide funnels and ask children to pour the colored sand into the containers that have holes in the lids. Put out the glue, trays, and construction paper.

2 Invite children to make sand art by creating a design with glue and sprinkling sand on top. When the glue dries, children can shake the excess sand onto the trays to reveal their glue-sand designs. Encourage them to run their fingers lightly over their designs to feel the texture of their creations.

3 Now use the sand to make a cooperative mural. Place mural paper on the floor or on the ground outside. Invite half of your group to squeeze glue designs on paper while the other children sprinkle sand onto the glue.

4 Allow time for the mural to dry, and then pick up the paper together to shake off the sand. Encourage children to decide on a title for their mural.

Observations

- Are children able to work cooperatively and share ideas as they create their mural? How do they resolve conflicts?

Books

Share these books about design. Encourage children to discuss projects that might stem from these books.
- *Dots, Spots, Freckles, and Stripes* by Tana Hoban (Greenwillow Books)
- *If You Take a Paintbrush* by Fulvio Testa (Dial Books)
- *It Looked Like Spilt Milk* by Charles Shaw (Harper & Row)

SPIN-OFFS

- Make colored-sand candles. Invite children to layer the colored sand into baby food jars until almost full. Then you or a volunteer can pour hot wax to top off the jar. Add a wick while the wax is still warm.
- Invite children to experiment with adhering other materials to a glue design. You can use small pieces of paper and natural materials such as pebbles, small shells, crumbled leaves, eggshells, and cotton.

Sandbox Castings

Use plaster in sand to make an "indelible" impression.

Materials

- outdoor or indoor sandbox
- watering cans
- water
- popsicle sticks
- spoons and small scoops
- putty or plaster of paris
- mixing containers

Warm-Up

Bring in or make a simple sand casting. For example, make a hand cast by pressing your hand into sand and filling the impression with plaster. After it dries, show the casting to children and talk about it together. Have children seen a casting before? How do they think this one was made? Discuss the process, and show children the putty or plaster they can use to make their own castings in the sand.

Activity

1 This activity works best in a sandbox or sand table outdoors, but it can be done indoors as well. Begin by providing watering cans and asking children to dampen an area of sand. Pass out popsicle sticks, and invite children to use them to fence off small areas where they can make their sand designs.

2 Encourage children to make any design they like but point out that it should be pushed into the sand, rather than built up high, to make a successful cast. Also invite them to collect natural objects like pebbles or leaves and press them into the sand to help create the impressions for their designs.

3 Provide spoons and scoops. Encourage children to experiment with these and natural materials until they create a design they want to save. When they are ready, ask them to help you mix the water with the putty or plaster of paris to the consistency of whipped cream. Then, together, pour it over their sand designs. (Work fast because the mixture dries quickly.) Ask children to predict what their castings will look like.

4 Let the material dry overnight. The next day, invite children to remove their castings and brush off the excess sand. Then talk about their creations. In what ways do they look the same or different from children's predictions?

Observations

- How do children use the materials to make designs?

Books

Share these books about sand on the beach.
- *Beach Day* by Helen Oxenbury (Dial Books)
- *One Sun* by Bruce McMillan (Holiday House)
- *Titus Bear Goes to the Beach* by Renate Kozikowski (Harper & Row)

SPIN-OFFS

- Work as a group to collect "safe" trash from around your school. Make a sand casting of each object. Then write down children's comments about the castings, and use them in a display about pollution.

Sculpture in a Bag
Children use plaster to sculpt their own creations.

Materials

- small lump of clay
- measuring spoons
- plaster of paris
- water
- plastic bowl for mixing
- plastic spoons
- 1 self-sealing plastic sandwich bag per child
- masking tape
- markers

Warm-Up

Initiate a discussion about sculpture by bringing a lump of clay to group time. Ask children how they might form the lump into a different shape. Invite volunteers to alter the lump of clay, and discuss the changes they make. Together, talk about the different materials that can be used to create sculptures.

Activity

1 Work in small groups, as plaster hardens quickly. First, help children make the modeling plaster. Measure two tablespoons of water and four tablespoons of plaster of paris per child into a bowl. Invite children to take turns mixing the ingredients with a plastic spoon.

2 Help each child pour a portion of the plaster mixture into one corner of a plastic bag and then seal it. Then put masking tape across the self-seal to keep the plaster from oozing out. Let the mixture set in the bag for a few minutes. During this time, encourage children to talk about their sculpture plans and make predictions about how the plaster will feel.

3 When the mixture has set but not hardened, invite children to squeeze the outside of the bags to shape the plaster inside. Encourage them to experiment, but remind them that they have a limited amount of time to shape the plaster before it hardens.

4 When children are finished, ask them to open the bags so air can get to the finished shapes. Allow at least 30 minutes for the sculptures to dry completely. Then provide markers for children to decorate their sculptures, if desired.

Observations

- Do children discuss the feel of the plaster in the bags? How does it influence their creations?

Books

Share with your sculptors these books about other kinds of changes.
- *It Looked Like Spilt Milk* by Charles Shaw (Harper & Row)
- *Little Blue and Little Yellow* by Leo Lionni (Astor-Honor)
- *Look Again* by Tana Hoban (Macmillan)

SPIN-OFFS

- Play a related movement game. Ask children to imagine that they are moist plaster or clay and that a sculptor is molding them. Play soft music, and encourage them to move their bodies as the imaginary sculptor alters their shapes.

Crayon-and-Paper Batik

This technique approximates the ancient art of batik.

Materials

- dishpan
- paintbrushes
- examples of batik cloth (optional)
- colored construction paper
- heavy white drawing paper
- brown tempera paint
- water
- crayons

Warm-Up

Introduce the art technique of batik, and, if possible, show some examples of batik cloth. Ask children how they think the batik patterns may have been created.

Activity

1 Start by asking children to draw a design with crayons on the white paper. Encourage them to press hard to make thick, dark lines. The process works best if papers are filled with lots of color.

2 Now help children dip their drawings in a pan of water, one at a time. Let each drawing sit for a few seconds, then remove. Have children gently crumple the wet paper into a ball. This will give it the crinkled batik look. (Don't let the paper absorb too much water, or it will become squishy and difficult to open.)

3 Next, invite children to open the crumpled paper and lightly brush it with brown tempera paint. Then place the paper back in the water to rinse off the paint. (If a paper appears too soggy, use a paper towel instead to blot off the brown paint.)

4 Remove the paper and lay flat to dry. Let the paper dry completely. After letting the batiks dry completely, mount on colored construction paper to display.

Remember

- Large amorphous or geometric shapes show the batik-like crackle effect best. Encourage children to make abstract designs, as representational drawings are likely to become blurred and fragmented.

Observations

- Do children make predictions of how their designs will be affected by the process?

Books

These resource books will provide unusual art techniques to try with children.
- *Crayon Crafts and Projects* by Kathy Faggella (First Teacher Press)
- *Don't Move the Muffin Tins* by Bev Bos (Turn-the-Page Press)
- *1-2-3 Art* by Jean Warren (Totline Press)

SPIN-OFFS

- Invite children to draw with crayons on pieces of medium-grade sandpaper, pressing hard. Then cover the sandpaper with white drawing paper, and you or another adult can press it with a warm iron. The crayon will melt onto the drawing paper, creating a drawing composed of dots. You can make several prints from one drawing.

Tissue Paper Collage

Here's an especially colorful version of this versatile technique.

Materials

- tissue paper of various colors
- chart paper
- white drawing paper
- marker
- spray bottle
- water
- scissors
- bowls
- liquid starch
- paper cups
- paintbrushes
- easel (optional)

Warm-Up

Tape a piece of tissue paper to white paper, hold it upright, and spray it gently with water. (You might want to do this on an easel.) Ask children to watch what happens to the color and to describe what they see.

Activity

1 Provide different-colored pieces of tissue paper, and set out the scissors and bowls. Let children rip or cut the paper into small pieces, and ask them to sort the pieces by color into the bowls.

2 Take a few minutes to talk about the colors children see. For example, ask them to group the bowls of paper into light and dark colors. Let them talk about their choices. Encourage children to discover dark and light versions of colors — for example, dark and light green or dark and light blue. Discuss whether all colors have dark and light versions.

3 Give each child a sheet of white paper. Then put out the brushes along with cups of liquid starch. Invite children that to make tissue paper collages by brushing a little starch on the paper, putting on a piece of tissue paper, and dabbing a little more starch over the top. Encourage them to use the materials to arrange and create their collages in any way they like.

4 When children have covered as much of the paper as they like, let the collages dry completely. They can be displayed on a wall or bulletin board.

Observations

- How do children describe the color changes they see?

Books

Share these books about feelings.
- *Feelings* by Richard Allington and Kathleen Krull (Raintree-Steck Vaughan)
- *I Have Feelings* by Terry Berger (Human Science)
- *Proud of Our Feelings* by Lindsey Leghorn (Magination Press)

SPIN-OFFS

- Talk about the idea that colors can express feelings. Encourage children to make collages using colors that seem to express a certain mood. Then ask them to make another collage expressing the opposite mood—for example, loud/quiet, happy/sad, peaceful/angry. Hang the collages in separate displays, and discuss how they make children feel.

Mosaic Pictures

Try another kind of collage for a very different effect.

Materials

- children's safety scissors
- paper scraps
- paste or glue
- 6"x 6" oaktag squares, 1 per child
- small containers with lids
- toothpicks or cotton swabs
- pictures of mosaics (optional)
- construction paper
- chart paper
- drawing paper

Warm-Up

Save scraps of paper left over from art projects. Show them to children, and ask them to suggest ways to use the scraps. Then write their ideas on chart paper, and plan to follow up on as many as possible. Suggest that one way to use these and other scraps is to make mosaics—pictures made from very small pieces of materials. Show pictures of famous mosaics, if possible, and explain that they are usually made from tile.

Activity

1 Give children scrap pieces of construction paper and scissors. Ask them to cut the paper into very small pieces, about 1/2 or 3/4 inches square. Cut a few yourself to show the size. Then ask children to sort the paper pieces by color into the small containers. You might want to repeat this step for several days to be sure you have plenty of scraps.

2 Let children experiment with gluing the colored pieces onto drawing paper to practice the technique.

3 Distribute the oaktag squares, and invite children to create mosaic pictures or designs. If the paper sticks to their fingers, offer toothpicks or cotton swabs to help with gluing.

4 As children work, encourage them to talk about their creative processes, share ideas, and ask each other questions. When children are finished gluing, put the mosaics aside to dry.

Remember

- This activity offers lots of cutting practice. Be certain your scissors are safe and easy to handle and are usable by right-handers, left-handers, and children with special needs.

Observations

- How do children solve problems such as how to create a specific shape out of the scraps?

Books

Here are some great art-activity books for small hands.
- *Art and Creative Development* by Robert Schirmacher (Delmar Publishers)
- *Don't Move the Muffin Tins* by Bev Bos (Turn-the-Page Press)
- *Scribble Cookies* by Mary Ann F. Kohl (Gryphon House)

SPIN-OFFS

- Ask children to work as a group to brainstorm a list of materials that might be used to create mosaics. You might experiment with bits of colored eggshells or seeds. Or ask for donations of small tiles from building supply stores, and let children set them in plaster.

Roller Printing

Children explore printmaking using their own designs.

Materials

- 1 plastic-foam tray per child
- paint rollers
- aluminum trays for paint
- tempera paint mixed with a little liquid detergent
- construction paper in dark colors
- popsicle sticks
- white paper
- sponges

In Advance

Make a simple print using a dry sponge. Lightly dip the sponge in paint, or brush paint over the surface. Press the sponge onto paper. Try to make the print as clear as possible so that the shape and texture of the sponge can be seen.

Warm-Up

Begin a discussion about printmaking by showing children you sponge print. Encourage children to guess how the print might have been made. Show children a clean, dry sponge and, together, discuss its texture. Is there a pattern or design on the surface of the sponge? Can you see that design in the print?

Activity

1 Give each child a plastic-foam tray. Help them find the bottoms of the trays, and then ask them to flip the trays so the bottoms are facing up.

2 Offer children the popsicle sticks, and invite them to etch a picture or design into the tray. Encourage them to think about what they want to draw before they begin and to share their ideas. As children work, encourage them to experiment. What happens if they make some lines deeper than others? Does it affect the paint print?

3 When children are finished with their designs, invite them to use the rollers to roll paint over their designs. Then ask children to press white paper on top of the tray to make a print. Remove the paper to see a print of the design on the tray. Encourage children to make several prints. Invite them to try using dark-colored paper and a light-colored paint. Encourage children to experiment with different combinations of paint and paper.

4 Ask each child to set out his or her tray and a print. Encourage them to talk about what they see and why they think the prints look the way they do. Invite them to look at other children's prints, ask questions, and share techniques.

Observations

- Are children able to predict what their prints will look like?

Books

Enjoy these books about children's paint creations.
- *Pablo Paints a Picture* by Warren Miller (Little)
- *The Big Orange Splot* by Manus Pinkwater (Hastings)
- *All I See* by Cynthia Rylant (Watts)

SPIN-OFFS

- Make prints using other textured materials such as leaves and sponges. Invite children to use the prints to make wrapping paper or stationery.
- During outdoor time, encourage children to look for natural objects that they think might work well for printing. For example, leaves have excellent textures for making interesting prints.

Activity Plans
for
Art&Language

A rt and language are natural companions. As children paint or draw, they often tell stories describing their own physical movements or the picture they are creating. Children enjoy talking about their creations with others. Art is also an incredible tool for self-expression. Children explore their feelings, ideas, even their capacity for role-playing — all through art.

Art is a natural component of literacy activities; encourage children to illustrate their stories, as well as to make up stories for their illustrations! Through different art media, the activities in this section encourage the development of children's language.

Teaching Tips

■ Model language by describing colors, shapes, and the processes you see in children's work. Your comments will help prompt children to express their own ideas.

■ Display art at children's eye level to encourage them to talk about the work they see.

■ Expose children to written language by inviting them to dictate or write stories about their artwork.

Self-portraits inspire children's language development by encouraging them to express themselves.

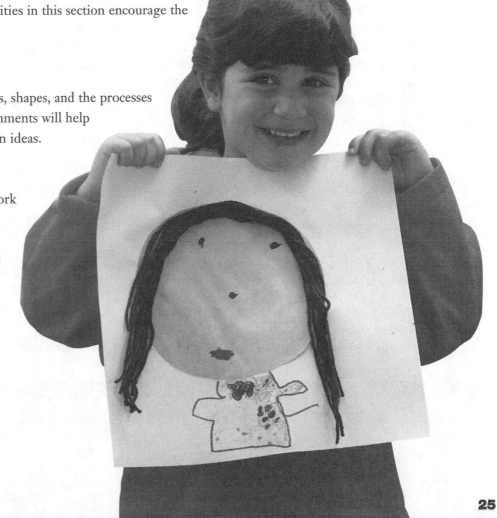

This Is Me

Children describe themselves through words and pictures.

Materials

- markers
- crayons
- 1 unbreakable hand mirror per child
- white drawing paper (heavyweight)
- magazines
- glue
- scissors

Warm-Up

Read a book such as *Is This You?* by Ruth Krauss (Scholastic) or one suggested below. Begin a discussion about all the things that make people who they are. Talk about things such as looks, abilities, interests, and families. Invite children to tell they group a few things about themselves such as "I have brown hair" or "I love spaghetti."

Activity

1 Invite children to make a collage about themselves on the white paper. Heavyweight paper will work best, as children will be drawing on the other side. They may choose to cut out magazine pictures of their favorite foods, toys, or animals. Children can also use crayons or markers to represent their favorite colors or to draw pictures.

2 Some children may want to label the items in their collage, using phrases such as "favorite food," "favorite color" or "my dog." Invite children to write or dictate their labels. When children have finished, set aside collages and allow them to dry completely.

3 Later, ask children to illustrate the other side of their papers with a self-portrait. Set out unbreakable mirrors along with crayons and markers in different colors, including a variety of skin tones. Suggest that children look carefully in the mirrors and really notice the shape and color of their hair, eyes, mouths, and so on.

4 When children have finished with their illustrations, invite them to share their collages and portraits with each other. Encourage children to explain what the items in their collages represent and ask each other questions. The finished products can be hung on a clothesline across the room so both sides can be seen. They can also be put together to make a class book.

Observations

How do children see themselves? Does this process seem to offer them new insight into themselves?

Books

Share these books about "me."
- *Andy, That's My Name* by Tomie dePaola (Prentice-Hall)
- *Hooray for Me* by Remy Charlip and Lillian Moore (Parents)
- *Just Me* by Marie Hall Ets (Viking)

SPIN-OFFS

- During circle time, invite children to create a class "me" poem. Ask each child to say something descriptive about themselves, and record their responses on chart paper. Children's sentences may begin "Jennifer is…," "Bob likes…," or "Alex has…." Hang up the poem for children to look at and discuss.

"All About Me" Boxes

These boxes provide unusual opportunities for self-expression.

Materials

- 4″ squares of paper
- scissors
- shoe boxes or gift boxes
- magazines and catalogs
- various collage materials including strips of colored construction paper
- at least 1 photograph of every child
- crayons or markers
- glue

In Advance

Collect photographs of all the children, either by asking them to bring some from home or by taking them yourself.

Warm-Up

Start this activity with a discussion about things that make each person unique, such as likes and dislikes or favorite activities. Then encourage children to share their thoughts by asking open-ended questions such as "What are some of your favorite things?" You may want to share information about yourself as well.

Activity

1 Gather a small group of children to make "All About Me" boxes. Look at the photographs you've gathered, and encourage children to talk about the pictures they are in. Ask each child to choose a box, and glue his or her picture in it.

2 Offer children magazines and catalogs, collage materials, paper, and markers or crayons. Encourage them to cut out or create pictures (on the small squares of paper) of their favorite things, places, or people. Then they can glue them into their "me boxes."

3 Be sure to give children plenty of time to work. Some might want to create their boxes over a period of days or bring small items or additional photos from home to include.

4 After everyone is finished, encourage children to take time to look at and talk about one another's creations. Invite families in to see them, too. Some children might want to dictate information for you to record, transcribe, and then display near their boxes. Children who are particularly involved in this project might want to use small gift boxes to make additional compartments. They can paste pictures and/or place items inside the smaller boxes and fit them into the larger one.

Observations

- What kinds of symbols do children use to describe themselves?

Books

Enjoy these books about "being me."
- *All by Myself* by Jean Tymms (Price, Stern, Sloan)
- *Look at Me* by June Goldsborough (Western)

SPIN-OFFS

- Use the "me box" idea to support curriculum themes. Children can glue drawn or cut-out pictures of feelings, seasons, animals, and so on.
- Make an "All About Us" book in which each child has a page about himself or herself. Children can discuss their differences and similarities.

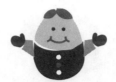

Mother Goose Puppets
Puppetry can bring nursery rhyme characters to life.

Materials

- a few mittens or socks
- posterboard or oaktag
- plastic-foam balls
- scissors
- stapler
- collage materials such as yarn, fabric scraps, paper scraps, buttons, sequins, and feathers
- markers and crayons
- paper plates
- popsicle sticks
- glue
- tape

Warm-Up

Introduce this activity with a simple homemade puppet. For example, you can make a Humpty Dumpty stick-puppet by cutting a piece of posterboard into an oval shape, drawing a face on it, and gluing it to a popsicle stick. Have the puppet recite its favorite nursery rhyme and "talk" to children about other nursery rhyme characters.

Activity

1 Recite several of children's favorite nursery rhymes together, and ask children to choose a nursery rhyme character they would like to make into a puppet. (Let them know they can choose a character from a rhyme you didn't recite.)

2 Show children the variety of materials available, and encourage them to discuss different ideas for creating their characters. If they need help getting started, you might suggest a few basic forms. For stick puppets, children can glue a popsicle stick to a posterboard shape, as suggested above, or to a paper plate. To make a ball puppet, help them poke a hole big enough for their finger in a plastic-foam ball. Or children can use a sock or mitten to make their puppets. Children can also invent other ways to make puppets.

3 Once children have decided on their basic puppet form, they can use materials to create a face, hair, and, if they like, clothes and props. Encourage them to think about what their character might look like, and help them problem-solve to represent those features with art materials.

4 When children finish, they can use their puppets. Some might want their puppet to recite its nursery rhyme to a group, while others might want to work with other children and puppets to act out a rhyme.

Observations

- How do children imagine their characters look? Are there books or pictures that may have influenced their ideas?

Books

These books and records lend themselves to puppetry.
- *The Elves and the Shoemaker* retold by Freya Littledale (Scholastic Cassettes)
- *The Gingerbread Man* by Karen Schmidt (Scholastic)
- *Tomie dePaola's Mother Goose* by Tomie dePaola (G. P. Putnam's Sons)

SPIN-OFFS

- Work together to create a puppet theater by cutting and painting a large appliance box or, more simply, by hanging a sheet over a table. Encourage children to rehearse acting out the nursery rhymes with their puppets before performing for the group.

Character Costumes

Paper bags and imagination bring story characters to life.

Materials

- unbreakable mirror
- paints
- marker
- tape and glue
- scissors
- various recycled materials such as juice cans, egg cartons, plastic-foam pieces, empty boxes, fabric scraps
- large paper shopping bags with attached handles (at least 1 per child)
- additional paper shopping bags
- chart paper

In Advance

Cut off the bottoms of the bags that have attached handles. Children can then wear the bags as costumes by stepping in and using the handles as shoulder straps. (Or, if necessary, you can attach straps using a stapler and heavy paper.)

Warm-Up

You can introduce this activity by reading a story that is a favorite of your class. Then encourage children to talk about the characters and their personalities or special features. Ask each child to name a favorite story character (be sure they understand that it can be from any story, not just the one your read). Talk about the characters in children's favorite stories. Ask each child to name his or her favorite, and record their ideas on chart paper. Invite children to make costumes and to dress up as the characters.

Activity

1 Set up two tables for this activity — one to hold the art materials and the other as a work space. Offer each child a prepared shopping bag. Let them try the bags on and check themselves in a mirror to see how they look.

2 Invite children to look at the materials and think about how to use them to create their costumes.

3 If children need help as they work, try to offer it indirectly by asking questions and offering choices. For instance, if a child wants to make a tail, you might ask, "What would happen if you used fabric scraps? Paper or pipe cleaners?" You might want to extend this activity over several days so children can really think, plan, and problem-solve.

4 Later, plan an event together in which children can wear their costumes. They might pretend to be their character as they act out stories.

Observations

- Do children try to re-create the ways the characters appear in books or adopt their own interpretations?

Books

These books include some all-time favorite characters.
- *Corduroy* by Don Freeman (Penguin)
- *Madeline* by Ludwig Bemelmans (Puffin Books)
- *The Giving Tree* by Shel Silverstein (Harper & Row)

SPIN-OFFS

- Children can extend this activity by making masks for their characters. The masks might emphasize special features of the characters, such as a particular color yarn for hair.
- Have a character parade. Children can wear their costumes as they march around the school. Afterward, have a party — children may even want to attend as their characters.

Class Yearbook

Children will star in their very own book about school.

Materials

- drawing paper (9″ x 12″ or larger)
- 1 candid photo of each child
- crayons
- stapler
- cardboard or oaktag
- markers

In Advance

Take a candid photo of each child doing an activity in the classroom. Attach each photo to one sheet of drawing paper; this will be the child's page. Prepare a front and back cover by cutting two pieces of oaktag or cardboard slightly larger than pages.

Warm-Up

Discuss with children the activities they do at school. What are their favorites? Their least favorites? Why? Show children that you have taken some of the photos of them in the classroom. They might be surprised! Explain that, together, you will be making a class book about what they are learning at school.

Activity

1 Give children their individual pages and photos and encourage them to remember the time the photo was taken. Ask questions such as "Do you remember what you were doing here? What did you like about the activity? What did you learn?" Ask children to write or dictate recollections or ideas about their pictures.

2 Invite children to decorate their pages with crayons and markers. They may want to use this creative opportunity to express more about themselves by using favorite colors, drawing a special design, or even extending the scene of the photograph to include friends and other areas of the classroom. Encourage children to talk about the designs they create. Are they representing other favorite activities?

3 Pass around the book covers and invite each child to decorate a section, creating a group design.

4 Staple the book together, and read it to the class. Invite children to tell each other about their pages. Encourage them to ask questions about other children's pages and to discuss the activities they do at school.

Observations

How do children describe their own activities? What do they feel they are learning at school?

Books

These books describe the trials and joys of school.
- *Is It Hard? Is It Easy?* by Mary M. Green (Young Scott/Addison-Wesley)
- *Rosa-Too-Little* by Sue Fett (Doubleday)
- *Timothy Goes to School* by Rosemary Wells (Dial)
- *Where Do You Go to School?* by Caroline Arnold (Watts)

SPIN-OFFS

- After creating the group book, children may be inspired to write and illustrate individual books about themselves.
- Take photos of children working in small groups, and invite them to make a "Friendship Book." Encourage groups to look at their photos together and work collaboratively to decide on text and design their pages.

Picture This

Children's stories develop through their own pictures.

Materials

- crayons
- stapler
- story paper (lined at bottom with space for pictures at top)
- cardboard or oaktag for covers
- favorite storybook

Warm-Up

Read a favorite story to the class. Before you begin, explain to children that you will not be showing the pictures. Ask children to close their eyes as you read and to picture in their minds what the characters and scenery might look like. Explain that the class will create their own pictures for the story.

Activity

1 Divide the story into scenes, and distribute them so that each child has one scene to illustrate.

2 Provide children with story paper and crayons, and encourage them to draw the scene as they imagined it. As children draw, invite them to talk about the details of the scenes they are depicting. How are characters interacting? What type of setting are they in?

3 Ask children to write or dictate the text of the scene on the lined portion of the paper. Encourage children to use their own words to describe the action.

4 Put the scenes in order, and then attach and bind the book covers to them. If the book is too thick to use a stapler, you may want to punch holes and tie the pages together with yarn or string. Read the class version of the story, and encourage children to talk about their pictures and interpretations. How did different children represent the same characters? Then invite children to look at the illustrations in the original story. What are the differences and similarities between their pictures and those in the book? How did that book illustrator use his or her imagination?

Remember

- Remind children that this is their version of the story and that it does not have to match the original. Provide them with positive support, emphasizing individuality.

Observations

- Notice children's interpretations of the characters. Which details of the story did they feel were important?

Books

Here are some fairy tales and folktales that may be well suited to this activity because of their familiarity.
- *Millions of Cats* by Wanda Gag (Coward, McCann)
- *The Three Bears and 15 Other Stories* by Anne Rockwell (Harper & Row)
- *Walt Disney's Three Little Pigs* by Barbara Brenner (Random House)

SPIN-OFFS

- Try an imagination exercise. Invite children to lie down on mats and close their eyes. Ask them to imagine a place they'd like to be, to picture it in their minds. Invite each child to describe their mental "pictures," encouraging everyone to include details such as colors, textures, sounds, and smells.

Happy Mobiles

Hang happiness all around your classroom!

Materials

- string or yarn
- markers and crayons
- 1 coat hanger per child
- old magazines
- drawing paper
- scissors
- stapler
- hole punch

In Advance

Start a mobile by attaching a couple of cut-out pictures to pieces of string and tying them to a coat hanger.

Warm-Up

Introduce the word *mobile* by showing children the one you started. Suggest that they make their own mobiles with pictures of things that make them happy. Then ask what kinds of things make them happy, such as favorite foods, special occasions, favorite activities, and cherished places.

Activity

1 Give each child a coat hanger and some string or yarn. Invite children to look through the magazines and cut out pictures of things that make them happy. They may also draw and cut out their own pictures. Some children may want to bring in things from home, such as pho-tographs or small objects.

2 Have children attach their pictures or objects to pieces of string, using a stapler or hole punch. Encourage them to use varying lengths of string so that each item can be seen clearly when the mobile is hung.

3 Help children tie their strings to the base of the coat hanger. They may need to adjust the balance of the hanging items.

4 Use a circle-time meeting for children to present their mobiles to the class. Encourage them to explain the significance of each item and why it makes them happy. Invite other children to ask questions of the presenter. For example, "What does your baby brother do that makes you happy?" Then hang the mobiles around the room for children to inspect at their leisure.

Observations

- What kind of questions do children ask each other about their mobiles? Which subjects seem to hold the most interest?

Books

This author has written a series of books about feelings.
- *How Do I Feel?* by Norma Simon (Whitman)
- *I Know What I Like* by Norma Simon (Whitman)
- *I Was So Mad!* by Norma Simon (Whitman)

SPIN-OFFS

- Children can expand on this activity, using different emotional themes such as "What makes me angry" or "What makes me sad."
- Children can further explore themselves by making books about their feelings. Invite them to draw pictures and write or dictate the text.

Setting the Stage

Stories come alive when children create colorful backdrops.

Materials

- roll of craft paper
- old newspapers
- paintbrushes
- pencils
- storybook with a specific setting, such as the jungle environment of *Where the Wild Things Are* by Maurice Sendak (Harper & Row)
- tempera paint
- paintbrushes

Warm-Up

Read the selected story to children, and begin a discussion about its setting. Where does the story take place? What are the special features of this environment? Explain to children that together they will make a "backdrop" for the story and then act out the different roles — just like a play.

Activity

1 Decide with children which area of the classroom would be best for hanging a backdrop. Discuss how big the backdrop should be, and cut the paper accordingly.

2 Clear an area of the floor for working, and then cover it with newspapers. Set out blank backdrop, paints, and brushes. Encourage children to discuss and share their ideas about elements that might appear in the backdrop, such as trees or water. Together, plan the scene and outline it roughly with pencil.

3 Invite children to paint different sections of the backdrop. Encourage collaborative work by reminding the painters to talk to each other about color and placement.

4 Hang the backdrop on the wall, and invite children to put on a performance of the story! Encourage children to use their own words for dialogue. They may also want to experiment with role-playing, acting out several versions and switching characters. The backdrop should be left up for children to use on their own as an option for choice time.

Remember

- Children have different amounts of experience with collaborative work. Some may need extra support to work in a group.

Observations

- Which roles attract which children? How do children use language in acting out the story?

Books

Here are a few examples of books with specific settings.
- *Curious George Goes to the Hospital* by Margaret and H. A. Rey (Houghton-Mifflin)
- *Deep in the Forest* by Brinton Turkle (Dutton)
- *Swimmy* by Leo Lionni (Pantheon)

SPIN-OFFS

- Children may want to expand on the theatrical experience by using props, costumes, and decorated furniture to resemble objects in the scene.
- Invite children to make up an original story that might take place in the same setting. Then they can put on a performance of their own play or story.

Round Robin

Children will create pictures for their own story.

Materials

- story paper (lined at the bottom with space for pictures at top)
- construction paper for covers
- chart paper
- markers
- crayons
- pencils
- stapler

Warm-Up

Gather children together and invite them to help write a story. Choose one child to begin the story with an opening sentence. Then ask another child, "What happens next?" Ask each child to contribute a sentence or two, with the last child ending the story. Write each contribution on chart paper, making sure to note who said what. Now invite children to draw pictures illustrating the part of the story they wrote.

Activity

1 Distribute drawing paper, and write children's contributions to the group story on the bottom of the page. Or ask children to copy them from the chart.

2 Before they begin drawing, encourage children to discuss their sentences, think about what takes place in that part of the story, and plan their illustrations. Where does the action take place? What will the characters look like and what are they doing?

3 Distribute markers and crayons, and invite children to draw their illustrations above the text. As children work, encourage them to talk about their drawings and share ideas with each other.

4 After assembling the book, gather children together and read the homemade picture book. Encourage them to talk about the story and illustrations. Did the story turn out silly? Did it make sense? What did they like or dislike about working with so many different authors? Invite children to make up a title and write it on the cover. Then add the finished book to your library for children to look at independently or as a choice for story time.

Remember

- Some children can have trouble translating their ideas into pictures. To help these children get started, ask supportive questions such as "What shape is the cat's head?"

Observations

- Do children continue the story in a way that makes sense? What connections do they make?

Books

Enjoy these silly stories with outrageous plots.
- *Hungry Fred* by Paula Fox (Bradbury)
- *In the Night Kitchen* by Maurice Sendak (Harper & Row)
- *Magic Michael* by Louis Slobodkin (Macmillan)

SPIN-OFFS

- As a variation on round robin, children may want to write a story as a group, deciding on characters and plot together. With this approach, children can discuss what should happen next, thereby creating a more cohesive story. You might want to use chart paper for the text and illustrations, creating an original "Big Book" by the class.

Activity Plans
for
Art&SocialStudies

A rt is a wonderful way to explore social studies in the classroom. Every culture has its own artistic crafts and traditions, allowing children to gain insight into the people who created them. Communal art activities can also be used to help children understand the diversity of cultures right in their own classroom. Creating and sharing art with friends and family is a very special way for children to deepen relationships and learn more about the people around them.

Exploring the artistic traditions of many cultures deepens children's appreciation of people around the world.

Teaching Tips

■ Plan for special projects through which children can work with each other in a cooperative setting. Prepare your area so that small groups of children can work comfortably together. By providing plenty of basic materials, you enable children to work on the same activity without arguing. Remember to step back and let children test their negotiating skills by trying to settle their own conflicts.

■ Assist children in noticing others' creations by showing interest in all children's works. Model ways to comment specifically and positively, such as noting use of color, special materials for texture, or innovative design.

■ Help children see what they can do for themselves. Let them discover what they can master on their own.

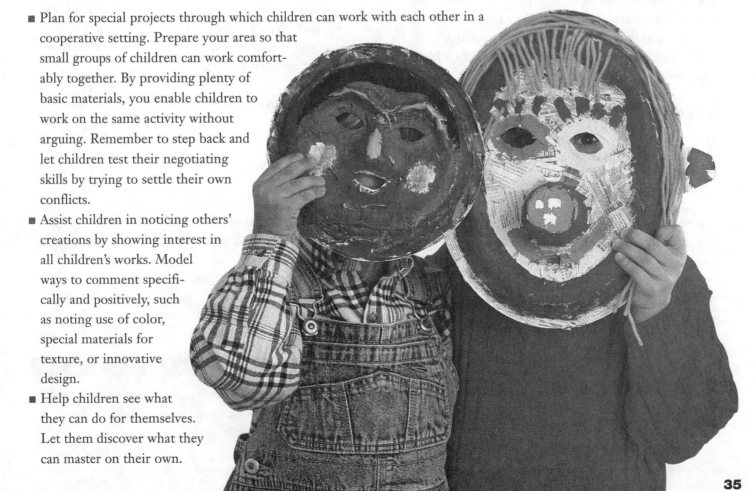

Shelters Around the World

Children learn about homes by creating their own shelters.

Materials

- collage and recycle materials such as small boxes, paper tubes, plastic-foam pieces, plastic containers, fabric and paper scraps, and straw
- pictures of various types of homes around the world
- chart paper ■ markers ■ crayons
- white glue ■ tape

Warm-Up

Gather children and talk about homes. Tell them about the type of home you live in, and ask them to tell about their homes. Then share pictures of different homes found in various environments. Discuss why all homes don't look alike. Help children notice that weather and available materials affect the way most homes are built.

Activity

1 Set out the art and recycle materials so children can create their own shelters. For ideas, they can look at the pictures and choose one of the homes they see, or they can invent their own kind of shelter.

2 Encourage children's creativity by posing questions and offering choices about the materials. For example, you might ask "Would fabric scraps work for your roof? Or could you use paper?" Children may think of using other materials as well. Someone might, for example, want to try a grass roof.

3 Give children plenty of time for this project. (Some may want to set it aside and work on it again the next day.) Encourage them to bring in unusual materials from home to add to their buildings.

4 When children are finished, invite them to share their shelters with the class. Encourage children to talk about the kind of environments their shelters would be in and their choices of materials.

Remember

- Children in your class may live in very different houses or neighborhoods. Increase children's awareness and sensitivity by modeling positive comments and avoiding negative comparisons.

Observations

- How do children choose materials for their shelters? Do they consider climate and inhabitants?

Books

These children's books offer a variety of settings.
- *Bringing the Rain to Kapiti Plain* by Verna Aardema (Dial Books)
- *The Crane Maidens* by Miyoko Matsutani (Parents Magazine Press)
- *People* by Peter Spier (Doubleday)

SPIN-OFFS

- Bring in a large appliance box, and invite children to work together to make it into a shelter. Children may want to cut out windows and doors and paint the house. They can also add decorations such as curtains or window boxes. Put the house in your dramatic-play or blocks area, or bring it outside to add a new dimension to children's play.

Papier-Mâché Masks

Masks from around the world can inspire children's creations.

Materials

- pictures of masks (and actual masks, if available)
- self-sealing plastic bags
- flour
- white glue
- newspaper
- tempera paints
- elastic strips
- warm water
- balloons
- knife
- safety pin
- hole punch

In Advance

Make a paste by mixing 1 part flour to 3 parts water, adding enough glue to make the mixture sticky. Refrigerate the paste in self-sealing plastic bags for several days before use. Then blow up one balloon for every two children in your group.

Warm-Up

Show children pictures of masks as well as samples of masks if you have them. Try to show a wide variety, such as African tribal masks and those worn for masquerade parties, Halloween, Día de los Muertos, and Chinese New Year parades. You might also include pictures of performers who wear masks as part of their work. Encourage children to talk about the masks and their similarities and differences.

Activity

1 Pour the paste into small bowls, and ask children to tear the newspaper into short strips. Help children form pairs, and give each pair a blown-up balloon. Help them to dip newspaper pieces into the paste and carefully cover their balloons with four layers of wet strips. Let the balloons dry for a day.

2 Pop the dry papier-mâché balloons with a safety pin. Cut each one in half with a knife to make two mask bases. Help children cut holes if they want them. Children can use more papier-mâché to build up eyebrows or noses.

3 Provide paints and other art materials for children to decorate their masks with. When they finish, punch a hole on each side of the masks and attach a piece of elastic string.

4 Invite children to put on their masks, and encourage them to talk about their creations.

Observations

- How do children describe their masks? What emotions or fantasies do they express?

Books

These books are useful for showing masks.

- *The Big Book of Animal Masks* by Angela Holroyd (Simon & Schuster)
- *The Big Book of Monster Masks* by David Antsey (Simon & Schuster)
- *Masks* by Danielle Sensier and Amanda Earl (Thomson Learning)

SPIN-OFFS

- Send a note home asking parents to donate clothing. Invite children to create costumes to wear along with their masks. Encourage children to use these items to role-play in the dramatic-play area. Children might make up a story or a play that incorporates their various costumes.

Piñata Time!

Create a game for a fun celebration.

Materials

- pictures of various cultural celebrations
- short stick or lightweight board
- old newspapers cut into strips
- healthy snacks, wrapped
- colored tissue paper
- collage materials
- broom handle
- liquid starch
- marker
- sturdy string
- masking tape
- large balloons
- large bowl
- small toys

Warm-Up

Discuss cultural celebrations. Why do people celebrate? How do different people celebrate around the world? Show children pictures of different cultural celebrations such as a Chinese New Year parade, a Mexican Fiesta, or a Mardi Gras party. Encourage children to talk about the kinds of celebrations they have with their families and friends. Then invite children to make a special toy used in Mexican celebrations.

Activity

1 Ask children if they have ever seen a piñata. Discuss what a piñata is (a large, breakable toy filled with little toys and treats) and how the game works. Children take turns wearing a blindfold and hitting the piñata until it breaks — and the goodies fall out!

2 Invite children to help make the piñata. Blow up a balloon, and help your group take turns soaking newspaper strips in the bowl of starch. Ask children to attach the strips to the balloon in flat layers, leaving a small space at the bottom for the treats to go in. Continue until the balloon is covered with at least three layers of strips. Let the piñata dry. (It may take a few days.)

3 Invite children to decorate the dry piñata with collage materials. Add a string for hanging. Then pop the balloon and invite children to help you fill the piñata with snacks and toys. Then cover the hole with tape.

4 Attach the end of the string to a broom handle, and hold the piñata at swatting level. Invite children to take turns being blindfolded and trying to break it with the stick.

Remember

- Create specific safety guidelines with children.

Observations

- How do children work collaboratively? How do they resolve conflicts?

Books

Here are some books about parties and celebrations.
- *Barn Dance* by Bill Martin, Jr. and John Archambault (Henry Holt)
- *Celebration* by Myra C. Livingston (Holiday House)

SPIN-OFFS

- Ask children to choose a favorite celebration they have at home. Then ask them to draw a picture and dictate a story about it. Encourage children to share their creations with others. Talk about similarities and differences among children's celebrations.

Fantasy Playground

Children build a model of their own ideal playground.

Materials

- recycle materials such as fabric and aluminum foil
- art materials such as markers and crayons
- camera (optional)
- unit blocks
- construction paper
- chart paper

Warm-Up

Begin a discussion about your school playground or local park. Visit the area, and, if possible, take pictures or draw a simple map to refer to later. Look for problems such as litter, areas that are unsafe, and areas that are not accessible to all children. When you come back, record on chart paper children's suggestions for improving the playground or park.

Activity

1 Using the photos or map as a guide, invite children to design what they consider an ideal park or playground. Help children to read their list of suggestions for reference. They can use blocks, art materials, and recycle materials. Encourage children to work collaboratively by sharing ideas and brainstorming to solve problems together.

2 Invite children to experiment and create additional props, like toy people to play in the park, or additional building materials. Encourage children to take their time in making decisions and creating structures. This activity works well as an ongoing project.

3 When children feel their model is completed, encourage them to discuss their creations and the reasoning behind them. Ask them to share their problem-solving techniques. Ask, "How did you decide which blocks to use for the seesaw?" Encourage children to ask each other questions about their building strategies.

4 Invite children to dictate a letter to send to local officials explaining their ideas for an improved park or playground. Try to take pictures of their model to send with the letter.

Remember

- Talk with children about the letter they send, and ask them what they think the result will be. To avoid disappointment be realistic about possible responses.

Observations

- How do children translate their suggestions into concrete structures and creations?

Books

Enjoy these books about parks and ecology.
- *The Little Park* by Dale Fife (Albert Whitman)
- *The Mountain* by Peter Parnall (Doubleday)
- *Wilson's World* by Edith T. Hurd (Harper & Row)

SPIN-OFFS

- Ask a local official to come to your classroom and talk about how improvements are decided upon and made in your town. He or she can describe what officials need to consider, who is involved, and so on.
- Explain what a survey is. Help children think of questions they could ask to get improvement ideas from other people who use the playground or park. Let them pair up to conduct the survey and then report back to the group.

A Mural Among Friends

Collaboration is the name of this game!

Materials

- collage items such as tissue paper, yarn, and fabric
- paints in various colors
- chart paper
- mural paper
- paintbrushes
- scissors
- markers
- glue

Warm-Up

Gather children together and initiate a discussion about friendships. Ask children what it means to be a friend and to have a friend. What kinds of things do friends do together? How do friends help one another? Record children's ideas on chart paper.

Activity

1 Clear an area of the floor to work on, then invite children to work together to make a Friendship Mural. Encourage children to talk about and plan how they will make their mural. Will they draw pictures as well as use the collage materials? In what ways can they represent their ideas about friendship in the mural? Place the chart paper near the work space for children to refer to as they work. Help them to read the chart to spur ideas.

2 As children begin working, encourage them to problem-solve together. Does everyone have enough room to work? Can several children work on one section of the mural together?

3 Extend children's thinking and collaboration by asking questions about their pictures and creations, such as "I see you drew you and Danielle playing with blocks. What other things do you two like to do together? Do you think she can help you get more ideas for your picture?" Invite children to use words in the mural as well. Offer markers and help children to label their friends or objects in the mural.

4 When children finish their mural, invite them to decide on a title together. Then help them choose a place to hang their mural. Encourage children to talk about the sections they worked on and to ask other children about their work. How does the mural look as a whole? Can you tell that many different people contributed to it? Encourage children to express their feelings about the collaborative work experience. What did they like about it? Were there any problems? How did they solve them?

Observations

- How do children adapt to working in a large group? What kinds of connections do they make with each other?

Books

Here are a few books about the importance of friendships.
- *The Bear Next Door* by Ida Luttrell (HarperCollins)
- *Friends* by Rachel Isadora (Greenwillow Books)
- *Making Friends* by Fred Rogers (Putnam)

SPIN-OFFS

- Invite children to participate in a special show-and-tell time about friends from outside the classroom. Children might bring a photo of their friend or show something special that their friend gave to them. Encourage children to talk about what makes their friend special and describe things they do together.

Secret Friend Art

It feels good to make a picture for a friend.

Materials

- collage materials such as paper cupcake holders, aluminum-foil scraps, wrapping paper, stickers, wallpaper, yarn, fabric, and ribbon
- 1 brown paper lunch bag per child
- construction paper or paper plates
- name card and photo of each child
- crayons or markers
- white glue

In Advance

Prepare the "secret friends" grab bags. Place an assortment of collage materials and a different child's photo and name card in each bag.

Warm-Up

Talk about the kinds of things friends give to each other. Ask children if they have ever made something for a friend, and encourage them to talk about what they did.

Activity

1 Tell children about the grab bags you prepared, and explain to children that they will make a picture for the friend whose photo and name is in the bag they choose. Explain that the friend they choose, as well as the materials for their pictures, will be a surprise. Talk about keeping the identity of their friend a secret.

2 Arrange the bags in a row on the table. Allow each child to choose a grab bag. Tell children to look inside to determine the identity of their secret friend.

3 Have children remove the collage materials from the bags but keep the photo inside for safekeeping. Encourage children to paste their collage materials onto their paper plates or construction paper to make special designs. Also suggest that they draw pictures of their secret friend or of things they know that person likes. Help each child secretly paste the name and photo of his secret friend on the back of his collage.

4 When the pictures are dry, invite each child to announce the name of his or her secret friend and to give that child the picture. Encourage them to talk about how it feels to give something you've made to a friend.

Observations

- Do any new friendships begin or develop as a result of exchanging presents with a secret friend?

Books

Here are some friends books to add to your library.
- *Do You Want to Be My Friend?* by Eric Carle (Thomas Y. Crowell)
- *A Kiss for Little Bear* by Else Minark (Harper & Row)
- *We Are Best Friends* by Aliki (Greenwillow Books)

SPIN-OFFS

- Look into developing a relationship with a kindergarten class in another school or with a local senior citizens' home or other social group. Let your children make secret-friends presents for the people there. Begin an exchange, and eventually arrange for a visit, if possible.

Class Friendship Shirts

Create a wearable symbol of community with your class.

Materials

- white T-shirts
- cardboard or folded newspaper
- colored laundry-markers or non-water-based paint

In Advance

Ask children to bring in old white T-shirts from home. Set the shirts out on tables, and put cardboard or newspaper between front and back to prevent designs from bleeding through to the other side.

Warm-Up

Introduce this activity by discussing the concept of community. How is the class a community? How do its members work and play together? How do they help one another?

Activity

1 Ask children to think of a symbol to represent themselves — their own "special sign." Some may want to write their names, use a symbol (like a football or a cat) to express something about themselves, create a special design, or any combination of these.

2 Have children draw or paint their symbols on a T-shirt.

3 Next, have children move one shirt to the right and re-create the image on that shirt. As children work their way down the line of T-shirts, encourage group conversations about their symbols and what they mean.

4 When children land at the shirt they started with, the project is complete. Everyone should have a shirt decorated with all of their classmates' symbols, including their own. Encourage children to talk about their finished T-shirts. How is each child's symbol different? How does the design work as a whole?

Remember

- Children have different tastes, and some children may not like what others have put on their T-shirts. Address potential conflicts by reminding children that everyone has a different style — the T-shirts are a way to celebrate those differences.

Observations

- Are children learning more about each other? How do they negotiate and resolve conflicts?

Books

These stories offer different perspectives on friendship and community.
- *A Chair for My Mother* by Vera B. Williams (Greenwillow Books)
- *The Little Red Hen* by Paul Galdone (Seabury)
- *Six Foolish Fishermen* by Benjamin Elkin (Children's Press)

SPIN-OFFS

- Together with children, plan a community celebration (such as the 100th day of school) and have each child contribute something different to the party. Everyone can wear their friendship shirts to the celebration!
- Extend children's ideas of community by inviting neighborhood volunteer workers to your classroom to talk about what they do. Encourage children to think of a project they'd like to do for the community and follow through on their plans.

Celebrate Giving
Children experience the joy of making gifts.

Materials

- 2 or 3 different paperweights
- baby-food jar or small plastic bottle (1 per child)
- colorful fabric circles
- colored chalk
- rubber bands
- sand or salt
- paper
- glue

Warm-Up

Start a discussion about giving. Talk about giving presents to family and friends. Ask children about the kinds of gifts they have given to special people in their lives. Does a present have to be bought? What other kinds of presents can we give? Invite children to make special gifts for their families.

Activity

1 Show children examples of paperweights, and ask if they can guess by the name what they are used for. Distribute the jars, and let children choose a piece of colored chalk. Place a few spoonfuls of salt or sand on a piece of paper, and help children to rub the chalk into it. (Rubbing the chalk against the salt or sand will cause the chalk to powder.)

2 When the salt or sand is colored, help children carefully fold their papers and pour the mixture into their jars. Now repeat the process with a different color mixture. This layer is then added on top of the first layer. Continue with new colors of sand until the jar is full. Then glue the lid on.

3 Now invite children to decorate the tops with cut circles of fabric that are about one inch bigger than the top. Drape over the lid and hold in place with a rubber band.

4 Encourage children to talk about the gifts they've made and how they will present them. Will it be a surprise? Some children may want to create wrapping paper for their gifts.

Remember

- The layers of sand can shift easily. Remind children to try to keep their jars upright when they carry them home.

Observations

- How do children feel about the act of giving? What do they think makes a good gift?

Books

Share these books about giving.
- *The Giving Tree* by Shel Silverstein (Harper)
- *A Birthday for Frances* by Russell Hoban (Harper & Row)
- *Ask Mr. Bear* by Marjorie Flack (Macmillan)

SPIN-OFFS

- Initiate a discussion with children about gifts that can't be wrapped, such as a hug or a favor for a friend. Ask children what kinds of gifts they can give that don't come in packages. Does it have to be someone's birthday or a holiday to give them a gift? Invite children to help create a class book about the nature of giving.

Portrait Partners

Children learn more about each other by taking a closer look.

Materials

- colored construction paper
- large paper bag
- scissors
- drawing paper
- crayons
- pencils

In Advance

For every two children in your class, take one sheet of colored construction paper and cut it into two puzzle pieces. You can do this by cutting in distinctive zigzag patterns. Try to use a variety of colors. Put the pieces into a bag.

Warm-Up

Introduce this project by reading a book about partners, such as *Frog and Toad are Friends* by Arnold Lobel (Harper & Row). Discuss things partners can do together, like see-sawing or playing leapfrog. Then explain to children that they will be pairing up to draw each other's portraits. Show children your grab bag, and invite each child to take a puzzle piece out of the bag without looking inside. When every child has a piece, encourage them to find the child who has the other half—that child will be their Portrait Partner.

Activity

1 Ask children to sit with their partners, facing each other across a table. Provide paper, pencils, and crayons. Encourage children to look at each other closely before they begin drawing. Help children to notice details by asking questions such as "How long is Jill's hair?"

2 Encourage children to plan their portraits in pencil before using the crayons. They may decide to draw a large portrait of their partner's face or a full-body portrait.

3 As children draw, encourage them to look up at each other for reference. Ask them to talk to each other as they work, asking questions and describing their drawing.

4 Label the portraits with the subjects' and artists' names, and hang them up for discussion. Later, children may choose to give the portraits to each other as gifts.

Remember

- Some children may not like the way their partner has drawn them. Address these potential conflicts by pointing out that all artists have very different styles.

Observations

- How do children see their friends? Does this activity provide insight into classroom relationships?

Books

Share with your class these books about friendship.
- *George and Martha* by James Marshall (Atheneum)
- *Sam and Emma* by Donald Nelson (Parents Magazine Press)
- *Steffie and Me* by Phyllis Hoffman (Harper & Row)

SPIN-OFFS

- Try a variation on this activity by having children choose secret Portrait Partners. Put children's names in a bag, and ask each child to choose one and draw a picture of that person. Then hang up the pictures and invite children to guess the names of the subjects and artists!

Activity Plans
for
Art&Science

Science and art are natural partners. We see this every time a child constructs a snowman or builds a sandcastle. Our natural environment provides countless opportunities to explore beauty and exercise creativity; encourage children to collect natural materials whenever they can. An interesting leaf, a twig, even a stone can provide new inspirations for young artists.

Teaching Tips

■ Plan for projects in which children can naturally discover how shapes can differ, fit together, and combine. Children will then begin to discriminate among shapes and become more aware of shapes in their environment.

■ Invite all children to experiment with variations of the same medium. For example, you may use watercolors, tempera paints, and dry paints so children can compare and contrast the outcomes.

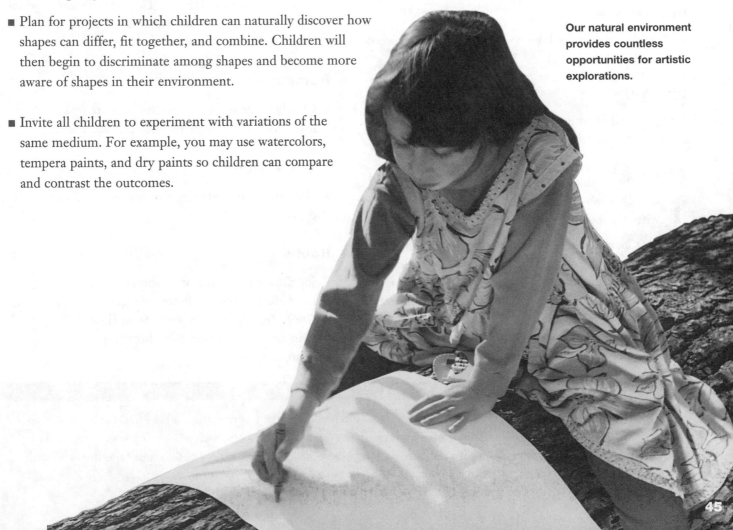

Our natural environment provides countless opportunities for artistic explorations.

Wind Sounds

These colorful chimes make wonderful sounds.

Materials

- wind chimes or pictures of wind chimes
- small, interestingly shaped branches
- hard-plastic drinking cups
- heavy-duty paper towels
- nail or ballpoint pen
- aluminum foil
- hammer
- cookie sheet
- markers
- yarn
- oven

In Advance

Preheat the oven at the lowest setting, and cover the cookie sheet with aluminum foil.

Warm-Up

Bring in wind chimes or pictures of wind chimes and talk about them. How do wind chimes make their sounds?

Activity

1 Take children on a nature walk, and ask them to collect twisted branches they can use to create wind chimes.

2 Back inside, give each child several plastic cups. Help children turn each cup over, place a paper towel over it, and make a hole in the bottom by gently tapping a nail or pen into it with a hammer. Then suggest that they use markers to decorate their cups. Encourage children to decorate cups with large, solid blocks of color, because thin lines tend to disappear when the cup melts.

3 Let children place the cracked cups upside down on the cookie sheet. Then put the sheet inside the oven and ask children to predict what will happen to the cups. Leave the sheet in the oven for a few minutes until the plastic melts into flat disks.

4 Allow the tray to cool for 10 minutes. Then help children string yarn through the holes and tie their chimes onto the branches they collected. Tie another piece of yarn to the top of the chime to hang it. Bring the chimes with you for outdoor playtime. Tie them to trees or whatever is appropriate in your setting. Invite children to listen to the chimes. When do they sound louder or softer?

Remember

- Closely supervise children when they are making the holes in the cups and when they are near the oven.

Observations

- How do children explain what happens to the plastic in the oven?

Books

Enjoy these books that feature sound.
- *Crash! Bang! Boom!* by Peter Spier (Doubleday)
- *Gobble, Growl, Grunt* by Peter Spier (Doubleday)
- *Noisy Book* by Margaret Wise Brown (Harper & Row)

SPIN-OFFS

- Investigate other ways that wind or air makes sounds. First, ask children to brainstorm a list of all the wind sounds they know, like rustling leaves and rattling windows. Then demonstrate others, such as blowing over the top of a glass bottle, letting air squeak out of a balloon, or playing a recorder or flute. Allow children to experiment with the materials.

Let's Make Wind Socks

Children "capture" the wind through wind socks they create.

Materials

- ornamental wind sock or a picture of one (optional)
- brown-paper lunch bags, 1 per child
- colorful streamers, crepe paper, and/or fabric strips
- experience-chart paper
- masking tape
- safety scissors
- markers and crayons
- yarn
- stapler

Warm-Up

Present this activity on a windy day. In a discussion about the wind, ask children how they know when the wind is blowing. What do they see? Can they really see the wind? Observe the wind from a large window or doorway, or, if possible, take a quick walk outside. Ask children to name the things they see that show the wind is blowing. Then make an experience chart of their observations.

Activity

1 If available, show your children a cloth wind-sock ornament or a picture of a wind sock used at an airport. Ask, "What does a wind sock show you? How is it used?" Point out the long tails found on a wind sock. Ask children how they think these move in the wind.

2 Ask children to cut the bottoms out of the lunch bags to form tubes. Then ask children to decorate the cut lunch bags with crayons and markers. Next, give them streamers or material strips to attach to one end of the bag with tape or a stapler. On the other end, ask children to tape pieces of yarn, about 8 inches long, to the four corners of their bag. Tie together the loose ends of all four pieces of yarn.

3 To hang the wind sock, tie one long piece of yarn to the four pieces of knotted yarn.

4 Take the wind socks outside, and let children hold them up in the wind. Encourage them to twirl, dance, or jump — whatever they like — to try and "catch" the wind. Some children might want to attach the wind socks to tree branches or play equipment and watch them blow.

Observations

- Do children have theories about what makes the wind blow?

Books

Here are some great books about air and wind.
- *Fish in the Air* by Kurt Weise (Viking)
- *Follow the Wind* by Alvin Tresalt (Lothrop, Lee & Shepard)
- *Sailing With the Wind* by Thomas Locker (Dial)

SPIN-OFFS

- For a simple wind activity, tape pieces of cloth to a table with masking tape. Let children decorate the cloth using markers. Then tape the finished flags to sticks or branches. Take them outside for a windy-day march around the playground.

Snow-Crystal Painting

Bring winter's snowy magic into your classroom.

Materials

- dark-colored construction paper
- pictures of snowy scenes
- Epsom salts
- bowls
- water
- glue
- crayons
- white paint
- glitter
- paintbrushes
- cotton

Warm-Up

Talk with children about winter and snow. If it doesn't snow in your area, ask children where they could go to see snow. Discuss how snow feels, looks, smells, even tastes. If possible, read one of the snow storybooks listed at the end of this activity and share pictures of snowy scenes from newspapers and magazines.

Activity

1 Ask children to think about and describe how snow and winter make them feel. If they've never seen snow, show them pictures again. Then ask them to imagine how they might feel in that type of place.

2 Invite children to help you make a "snow-crystal mixture." In a bowl, mix one-half cup water with one-half cup Epsom salts. Stir well with a paintbrush. Discuss how

the mixture looks and feels. How is it similar to snow? How is it different? Encourage children to try brushing glue on paper and sprinkling the snow-crystal mixture onto the glue.

3 Put out the snow-crystal mixture along with crayons, white paint, paintbrushes, cotton, and glitter. Ask children to think about how they would like to use their materials to create their visions of a winter wonderland on construction paper. Encourage children to experiment with flat and three-dimensional images.

4 Ask children to think up titles for their winter art creations. Then display their art in your classroom, and encourage children to talk about the different scenes and how the effects were created.

Observations

- How do children use the five senses (sight, sound, touch, taste, and smell) to describe the snow?

Books

Here are some books to add to your winter storytimes and discussions.
- *Dear Rebecca, Winter Is Here* by Jean Craighead George (HarperCollins)
- *Snow* by Nancy Elizabeth Wallace (Artists and Waters)
- *Walk on a Snowy Night* by Judy Delton (HarperCollins)

SPIN-OFFS

- For another winter art project, collect white collage materials such as cotton, plastic-foam pellets, buttons, ribbons, and white chalk. Let children draw and paste on dark construction paper. Then talk about what happens to plants during the winter. Amass a collection of leaves or berries from plants that thrive in your area in winter—for example, evergreen needles or holly berries. Then invite children to add these to their collages.

A Winter Arts Festival

Let snow and ice inspire children's creativity.

Materials

- pictures of magnified snowflakes
- finger-paint or freezer-wrap paper
- empty salt or pepper shakers
- plastic-foam packing pellets
- dark paper
- dustless chalk in various colors
- ice-cube trays
- popsicle sticks
- toothpicks
- food coloring

In Advance

Prepare ice-cube "paintbrushes" by filling an ice-cube tray with water and standing a popsicle stick in each cube. (The sticks don't need to stand up straight.) Then make a second tray of colored "paintbrushes" by adding food coloring to the water before freezing. Now shave pieces of dustless chalk onto a piece of paper, and pour into an empty salt or pepper shaker.

Warm-Up

Have a discussion about ice and snow. Invite children to talk about their experiences with ice and snow. What kinds of things can be made from ice and snow? What are some of the ways it can be used?

Activity

1 Set up a table for each of the activities. Children can move from one table to the other, experimenting with all of the materials. Or do these activities over several days, and culminate with a Winter Art Show.

2 To make "snow sculptures," place the plastic-foam pellets and toothpicks in the center of your worktable. Invite children to create their own snowflakes by connecting the pellets together with toothpicks. Display the completed snowflakes on dark paper.

3 To do "icicle painting," offer children sheets of shiny finger-paint paper and the prepared ice-cube "paintbrushes." Invite them to sprinkle the colored chalk from the shakers onto the wet parts of the paper. As a variation, offer children the precolored ice-cube paintbrushes. Talk about the colors. Are they the same or different?

4 After all the creations have been completed, put on an art show. Display children's work in your classroom, and invite families in to share it.

Observations

- How do children go about constructing their snowflakes? How do they describe the melting materials in "icicle painting"?

Books

Share these wintry stories with children.
- *Biggest Snowstorm Ever* by Diane Paterson (Dial Books)
- *Josie and the Snow* by Helen Buckley (Lothrop, Lee & Shepard)

SPIN-OFFS

- Put on some instrumental music and encourage children to move like flowing water. When the music stops, children freeze into an ice shape. Start the music again, and let children "melt" into water.
- Conduct ice-melting experiments. For example, ask children to predict how long it will take an ice cube to melt in the refrigerator, on the windowsill, and on the radiator. Encourage them to test their predictions.

A Spring Day Mural
Bring the colors and wonders of spring indoors!

Materials

- collage materials such as paper cupcake holders, pipe cleaners, construction paper, tissue paper, seed catalogs, cotton balls, and other materials children suggest
- mural paper
- chart paper
- markers
- scissors
- glue
- crayons

Warm-Up

Gather the whole group for a discussion about spring. Invite children to talk about changes in nature that they think mark the spring season. If possible, go on a neighborhood walk and encourage children to point out the signs of spring they see. Back inside, record children's discoveries on chart paper.

Activity

1 Invite children to make a spring mural. Review the chart you made, and ask children what they would include in a big picture about spring. Show them the materials you've gathered. Encourage children to plan how they will use them—for example, which items would make good clouds, which might make good trees, and so on. Ask children to brainstorm a list of other materials they might like to include. Then encourage them to help you collect as many as possible from around your classroom. Children may also want to collect natural materials from outdoors.

2 Clear an area of the floor to work, and tape your sheet of mural paper to the floor. Put all art materials on a nearby table. Then invite children to create. Keep the chart nearby for children to refer to as they work. Encourage children to talk to each other about their choice of materials and what they are making.

3 Invite children to use words in the mural as well. If they like, help children to label their signs of spring.

4 On a warm day, take your spring mural outside. Attach it to the side of the building, and encourage children to look for the items represented in their mural. Are there any they would like to add? Encourage children to make connections between the spring day and the spring scene they created.

Observations

- What symbols do children use to represent spring?

Books

Share these delightful spring books.
- *The Bear Who Saw Spring* by Karla Kuskin (Harper & Row)
- *The Day the Sun Danced* by Edith Hurd (Harper & Row)
- *The Rain Puddle* by Adelaide Hall (Lothrop, Lee & Shepard)

SPIN-OFFS

- Invite children to make up stories about the plants, animals, people, and objects shown in the spring mural. Record their stories on chart paper, and hang them around the mural in your classroom. Invite families or other classes to see your spring display.

Flower Power
Use wildflowers as an art material.

Materials

- samples of flower crafts, such as dried-flower arrangements or pressed flowers
- small pieces of colored tissue paper
- clear contact paper
- stick pin
- glitter
- 1 paper bag per child
- paper towels
- scissors

Warm-Up

Bring examples of flower crafts to group time for discussion. Ask children how they think the flower crafts were made. Encourage children to think of others ways that flowers can be used to make things.

Activity

1 On a warm, sunny day, give a paper bag to each child. Take a walk to a park or playground where children can find wildflowers and grasses. Remember, even the smallest, most ordinary flowers are great. (If this step is not possible in your area, collect and bring in wildflowers ahead of time.) Gently press the flowers in paper towels, or let them lay awhile in the sun to remove moisture.

2 Lay out the flowers and other art materials on a table. Show children the materials, and invite them to use them to make their own pressed-flower crafts. Cut wide pieces of the clear contact paper, and help children peel off the backing. Then ask them to hold the strips of contact paper in front of them, sticky side up.

3 Invite children to place flowers, paper, and glitter on half of the paper. Explain that they will be folding over the other half to close it.

4 When they finish, help children carefully fold over the self-adhesive paper, pushing out air bubbles as they press the paper to seal it. (Later, you can use a pin to prick any remaining bubbles.) Encourage children to think of ways that they can use the crafts. For example, children might use them as bookmarks or window decorations or give them away as gifts.

Remember

- Talk with children about when and where it is permissible to pick flowers.

Observations

- Do children notice the differences among flowers they picked?

Books

Share these books about flowers.
- *Counting Wildflowers* by Bruce McMillan (Morrow)
- *Flowers* by Rene Metler (Scholastic)
- *What's Your Favorite Flower?* by Allan Fowler (Children's Press)

SPIN-OFFS

- Set out dried flowers in an empty vase and fresh-cut flowers in water. Use the same type of flower, if possible. Ask children to draw and describe the flowers daily, looking for changes.
- Make dried-flower bouquets. Gather the stems of flowers together and bind them with a rubber band. Hang them upside down indoors, away from sunlight and dampness, for about one to two weeks.

Making Nature's Paint

Children will use natural materials to make their own paints.

Materials

- assorted natural materials like fresh red cabbage, blueberries (fresh or canned), onion skins, coffee grounds, beet juice, and flower heads
- hot plate, stove, or electric frying pan
- small watercolor paintbrushes
- blender or food processor
- large wooden spoons
- small pots
- experience-chart paper
- smocks
- water
- white paper

Warm-Up

Gather everyone and take a walk outside to look at colors. Talk about trees, grass, flowers, and even people's clothing. Help children look closely at colors. For example, with close inspection, children might notice that there are many colors in grass besides green — brown, yellow, even blue.

Activity

1 Talk about colors and where they come from. Explain that many colors are made from chemicals but that different plants and vegetables are also used to make colored dyes for clothing and paints. Show children your selection of natural materials. Then ask them to predict what color they think each will make. Record their ideas on chart paper.

2 To begin making dyes, help children peel and dice each fruit or vegetable. Onion skins should be crumpled; coffee can be used as it is. If you are using canned items, use the juice as well as the fruit.

3 Simmer each fruit or vegetable in a separate pot on low heat. Add small amounts of water or natural juice to the dry materials, stirring each of the contents occasionally. (If possible, have a volunteer do this step so you can watch with children from a safe distance and talk about the changes they see.)

4 When colors darken considerably, remove them from the heat and allow to cool. Compare the resulting colors with children's predictions. Then let everyone put on smocks, grab a paintbrush and white paper, and create with their homemade colors!

Remember

- Natural dyes may stain clothing. You might want to use extra-large smocks with sleeves or ask children to bring in an adult-sized old shirt for painting.

Observations

- Can children predict what colors the materials will make?

Books

Here are stories to make your day more colorful.
- *Color Seems* by Iama Haskins (Vanguard Press)
- *Little Blue and Little Yellow* by Leo Lionni (Astor Honor)
- *Open Your Eyes* by Roz Absich (Parent's Magazine)

SPIN-OFFS

- Ask families to donate a spare pair of white socks for their child. Let children dip the socks into the colors to make dyed clothing!
- Encourage children to brainstorm other ways that people use plants: for food, decorations, and even medicine. Discuss safety rules, such as never eating or touching unfamiliar plants.

Creative Gardens

Children use grass seed and natural materials to create gardens.

Materials

- natural materials such as twigs, pebbles, seashells, walnut shells, and eggshells cracked in half
- plastic or plastic-foam meat trays
- experience-chart paper
- marker
- plastic forks
- pencil
- potting soil
- grass seed
- spray bottle

Warm-Up

Visit a local garden or garden center, or find books about gardens in your local library. Back in your classroom, discuss gardens. What is a garden? What is needed to help them grow? Record children's responses on an experience chart.

Activity

1 Invite children to make their own gardens. Offer each child a plastic-foam meat tray, and help them use a pencil to poke a few holes in the bottom for drainage. Help children fill their trays with about an inch of potting soil, sprinkle the soil with grass seed, and use plastic forks to gently rake the seeds into the soil. Have children take turns misting their gardens with plenty of water from the spray bottle.

2 Place the trays near a sunny window. Each day, ask a different child to water the gardens using the spray bottle. Observe and discuss your gardens as they grow.

3 When the grass reaches about a half-inch, show children the stones, twigs, and shells you collected. Invite them to use these materials to decorate and individualize their gardens. Let them know they can use any other materials available in your classroom. They might, for example, want to use clay or paper.

4 As they work, encourage children to talk about what they are creating and what items they are using to create it. Perhaps a twig represents a tree, a seashell filled with water is a pond, and small pieces of aluminum are shiny fish.

Remember

- This is a good project to continue over time. Keep children's creations near a sunny window, and encourage them to add to or change their gardens as they choose.

Observations

- What creative ways do children use to represent things in their garden?

Books

Share these books about growing gardens.
- *In the Tall, Tall Grass* by Denise Fleming (Holt)
- *A Little House of Your Own* by Beatrice S. DeRegniers (Harcourt Brace Jovanovich)
- *Planting a Rainbow* by Lois Ehlert (Harcourt Brace Jovanovich)

SPIN-OFFS

- Encourage children to make up stories about their creative gardens. Display the stories near the gardens.
- Plan a real garden. Research different seeds, and decide with children which to grow. Make a grid on chart paper, and divide it into sections. Together with children, decide on a layout plan and tape the seed packets to the appropriate spots. Outside, dig a garden, dividing sections with string. Then help children plant the garden according to their plan.

Weaving for the Birds
Children can help birds prepare their nests.

Materials

- natural materials such as yarn, cotton fabric strips, string, twine, fabric ribbons, and dried grasses or weeds
- coat hangers or large dead branches with many offshoots
- pictures of bird nests
- bird nest (optional)

Warm-Up

If available, show children a bird's nest, or look at pictures of nests. Investigate how they were made and what materials were used. Ask children where they think birds get materials to make their nests. Talk about what kinds of nesting materials birds in your area would find.

Activity

1 In spring, take a walk outside together to look for materials birds might use to make their nests. Guide children to collect clean things, like long grasses and thin sticks. Add these to the materials you already have.

2 Children can use dead branches or stretched-out coat hangers as bases for their weaving. To make a warp, help children wrap lines of yarn onto the base in a grid-like pattern, either from branch to branch or from side to side of the hanger. (A warp is made of long pieces of yarn or string that other materials can be woven through.)

3 Now it's time to weave. Encourage them to be creative in selecting materials they want to use and to weave them in their own ways, but remind them to keep their weaving loose and to leave long ends hanging. This makes it easier for birds to take the materials for their nests.

4 When children's weavings are complete, hang them outside in a place where you can watch birds remove the materials. You might ask, "How long do you think it will take the birds to pick everything off? Which materials do you think will be most popular?" Later in the spring, take a walk to look for the local nests your group helped create!

Remember

- Remind children that birds will not come back to the nests if they have been touched by humans. Always wait until a bird has finished with a nest before exploring it.

Observations

- Can children predict how birds will use the materials?

Books

Try these books to add a literature component to this activity.
- *Frederick* by Leo Lionni (Alfred A. Knopf)
- *The Goat in the Rug* by Martin Link and Charles L. Blood (Parent's Magazine Press)
- *It's Nesting Time* by Roma Gans (Thomas Y. Crowell)

SPIN-OFFS

- Make a graph of the materials children use in their weaving. Note how much of each material is used. Then keep track of how many of each material the birds take. Talk about which materials were most useful to birds.
- Offer more weaving experiences. For bases, provide a commercial weaving board or cardboard cut into different shapes, with half-inch slits cut around the sides. For weaving, supply yarn, string, or sewing trim.

Activity Plans
for
Art&Math

Mathematical concepts are a part of many works of art. Pattern, shape, direction, perspective — what would art be without them? Encourage children to identify shapes and find patterns in their own creations as well as in the work of others. When children decide which colors to mix, how to create a sturdy structure or how to extend a pattern, they are building mathematical skills.

Art is an active and creative way to explore math with all children, and can be particularly helpful to those children who seem to shy away from other types of math activities. The activities in this section are designed to help children learn concepts through action.

Teaching Tips

■ Encourage children to talk about the projects they're doing while they are doing them. This will help you to understand children's reasoning skills.

■ Encourage children to predict results, such as what will happen when they mix the colors blue and yellow together.

■ Let children follow through on their own plans even if their reasoning is faulty. This will allow them to make their own discoveries — to learn through the process. You may find that they are able to redirect or correct themselves as they work. If not, take time afterward to help them brainstorm more workable methods.

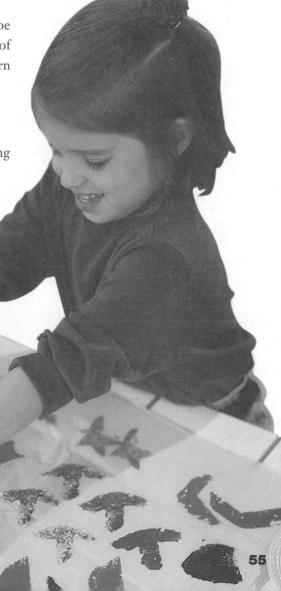

Noticing the aesthetic quality of patterns is one way for children to explore math concepts through art.

Fold It, Bend It, Shape It!

Children brainstorm ways to transform the shape of paper.

Materials

- paper strips of various colors, lengths, widths, and textures
- large sheets of construction paper
- scissors
- glue
- tape

Warm-Up

Offer everyone a few paper strips, and encourage children to describe what they see. Talk about how the strips are alike and different. Then encourage children to think of things they might do to change the way the strips look or feel. Invite children to try a few techniques such as tearing, folding, twisting, or crumpling.

Activity

1 On your art table, set out the remainder of the paper strips, scissors, glue, and tape. Offer each child a sheet of construction paper as a base, and encourage them to use the strips any way they like to create an art project. Children might experiment with three-dimensional shapes to make a paper sculpture, use flat shapes for a collage effect, or a combination of these.

2 Allow plenty of time for children to think and create. To get them started, you might ask, "Would you like to glue the strip down flat? Or would you rather try folding

or ripping it first?" Encourage children to talk about their methods and help each other with problem solving.

3 After children have had a chance to explore, demonstrate a few paper-changing techniques. Show them how to make an "accordion" by making a narrow fold, turning the paper over, and then repeating the process again and again. They might enjoy curling the strips around a pencil. Encourage children to incorporate these techniques into their creations.

4 Invite children to share their completed creations with the group. Encourage them to ask one another questions about the methods they used and the problems they encountered and solved. Invite children to talk about the similarities and differences they see. Then display the paper creations in a special place in the room for children to look at independently.

Observations

- Do children try many new techniques for changing paper? How do they solve problems?

Books

These books use paper in interesting ways.
- *Chicka Chicka Boom Boom* by Bill Martin, Jr. (Gryphon House)
- *Everyday Pets* by Cynthia Rylant (Bradbury Press)
- *Let's Make Rabbits* by Leo Lionni (Gryphon House)

SPIN-OFFS

- Provide a large piece of cardboard, and add more strips cut from wallpaper books and magazines as well as from regular paper. Encourage children to work together to create a three-dimensional design.
- Do paper weaving. Cut vertical slits in a letter-size sheet of construction paper, leaving the edges of the paper intact. Help children pull other paper strips through the slits, weaving under and over the base.

Invent a Machine

Envision an invention, then create it with scrap materials.

Materials

- drawing paper
- chart paper
- brass paper-fasteners
- masking tape
- pencils
- white glue
- safety scissors
- markers
- 1 shoe box, cereal box, or oatmeal cannister per child
- recycle materials such as popsicle sticks, telephone wire, yarn, plastic-foam pieces, paper plates, wood scraps, spools, cloth scraps, paper tubes, and egg cartons

Warm-Up

Have a discussion about machines. Ask children to brainstorm all the machines they can name, and record their answers on chart paper. Talk about the kinds of things various machines do and how they are alike and different.

Activity

1 Ask children to think about a machine they would like to invent. They can design it to do anything they want—like put away the blocks at cleanup time or make their bed at home. Invite children to draw a pencil sketch of what their machine might look like.

2 Invite children to create models of their machines using recycled materials. Invite each child to choose a box or cylinder as the base for his or her machine. Provide glue, tape, safety scissors, and fasteners for attaching parts.

3 Put out the collection of recycle materials, and encourage children to use these to create parts for their machines. Pose open-ended questions to encourage problem solving, and encourage children to share their ideas with each other as they work.

4 As children finish, ask them to tell you about their invention, including what it is called and how it works. Can they explain where, how, and by whom it is used? Record children's words on index cards, or encourage them to write themselves. Display the machines along with their descriptions in your classroom, and encourage children to ask each other about their inventions and how they work.

Observations

- How do children make connections between the parts of their machines and their functions?

Books

The following books are excellent for discussions about machines and tools.
- *Dig, Drill, Dump, Fill* by Tana Hoban (Greenwillow Books)
- *Machines* by Anne Rockwell (Macmillan)
- *Simple Machines and How We Use Them* by Tillie S. Pine (McGraw-Hill)
- *The True Book of Toys at Work* by John Lewellen (Children's Press)

SPIN-OFFS

- Talk about simple inventions children use every day, such as zippers or markers. Choose a few to learn more about. Take a trip together to your local library to research answers to children's questions.
- Ask children to look through magazines and cut out pictures of machines such as computers, vacuum cleaners, and airplanes. Brainstorm ways to categorize the machines, such as function or size.

Gadgets Galore

Sort everyday materials, and use them to make rubbings.

Materials

- muffin tins or egg cartons
- peeled crayons
- assorted household gadgets such as paper clips, spools, safety pins, washers, toy pieces, small scissors, and pieces of metal screening
- thin-gauge white drawing paper
- small paper bag
- masking tape

In Advance

Fill a paper bag with gadgets such as those listed above. You might invite a few children to help you decorate the bag, but keep the contents a secret.

Warm-Up

Talk about the word *gadget*. What is a gadget? What does it do? Show a few examples of gadgets, like a vegetable peeler or a paper clip. Explain that a gadget is like a tool people can use to help them make or do things.

Activity

1 Take out your mystery bag filled with gadgets, and invite children to guess what's inside. To help them make their guesses, let them shake the bag and reach inside without looking.

2 Now take out the gadgets. Go over the gadgets one by one, inviting children to name them and describe how they are used. If some objects are unfamiliar, encourage children to try to figure out how they could be used.

3 Put out the muffin tins or egg cartons as sorting containers. Talk about different ways to sort the items into the separate compartments — by color, for example, or size. Decide together how to sort items that don't fit easily into a category. Then try re-sorting the gadgets by other categories like shape, texture, or use.

4 Provide crayons, and tape a sheet of paper to the table. Help a child to place a gadget under the paper and rub over it with the side of a peeled crayon. Talk about the image that appears. Then encourage children to choose gadgets, and help them tape down their papers so they can make rubbings. They might like to do one rubbing at a time or arrange their gadgets in a design and rub them all at once.

Observations

- How do children use sorting skills as they group gadgets?

Books

Here are some books about gadgets and tools to add to the story corner.

- *Bam! Zam! Boom!* by Eve Merriam (Scholastic)
- *Dig, Drill, Dump, Fill* by Tana Hoban (Greenwillow Books)
- *My Very Fist Book of Tools* by Eric Carle (Crowell)

SPIN-OFFS

- Repeat the activity, using natural materials. Gather children and go out on a walk to collect leaves, twigs, pebbles, and so on. Sort them into muffin tins, and use them to make rubbings.
- Offer children clay and encourage them to select a few gadgets to press into the clay to make imprints. Suggest that they set out their gadgets next to the clay, and challenge other children to match the imprints to the gadgets that made them.

Problem-Solving Art

Task cards challenge children to create with shapes.

Materials

- oversized manila envelopes
- crayons or markers
- basic-shape stencils of various sizes
- construction paper of various colors
- posterboard cut to about 8″ x 11″
- index cards
- scissors

In Advance

- Cut out shapes from construction paper, using stencils if you wish. You will need about 50 to 100 shapes.
- Then use index cards to make 5–10 task cards that pose problems to be solved using shapes. Ask questions such as "Can you use circles and squares to make a car?" or "Can you use only different-size circles to make a tree?" Try to use pictures and only a few words.

Warm-Up

With children, look around your room and notice the shapes of objects such as signs, toy trucks, and blocks. Then show children some of your pre-cut shapes. Then, together, experiment with arranging them into the shapes of the objects that children see in your classroom.

Activity

1 Work with a few children at a time. Show them the task cards, and ask them to help you select about 10 pre-cut shapes that can be used to solve each one. The "car" task, for example, would require circles and squares.

2 Next, ask children to help you assemble "problem-solving packets" by placing one index card, its accompanying shapes, and a piece of posterboard into a manila envelope. Encourage children to label the envelopes according to the task card inside by drawing a picture.

3 Now introduce the cards to your whole group. Read each problem aloud together. Explain that children can choose a packet, "read" the task card, and arrange the shapes on the posterboard to solve the problem.

4 Place the cards in your math/manipulatives area for children to use independently. Encourage them to try several solutions for each problem. Then put out blank cards and envelopes, and invite children to create new task cards for others to try.

Observations

- Do children experiment with different solutions?

Books

Add these shape-related books to your library.
- *The Amazing Book of Shapes* by Lydia Sharmon (Dorling Kindersly)
- *My Very First Book of Shapes* by Eric Carle (HarperCollins)
- *Shapes, Shapes, Shapes* by Tana Hoban (Greenwillow Books)

SPIN-OFFS

- Make "starter pictures" by pasting one or two shapes on paper, and then pose a problem. You might ask, "Can you make this into something to live in?" or "Can you make this into something to eat?" Children can add crayon drawings or more shape cutouts to complete the pictures.

Paper Possibilities

Children sort and match paper of different colors, sizes, and shapes.

Materials

- trays or paper plates for sorting
- experience-chart paper
- various paper, such as construction paper, tissue paper, wrapping paper, and self-adhesive paper
- additional paper and paper products children bring from home
- safety scissors
- marker

In Advance

Send a letter to families explaining that you will be doing activities about paper. Ask them to save and donate clean scraps of paper and paper products.

Warm-Up

Ask children to brainstorm a list of different types of paper and things made from paper. Record their ideas on an experience-chart.

Activity

1 Explain to children that you are asking their families to donate scrap paper for a project. Then ask children to take an imaginary walk through their homes and name different kinds of paper they might find. Add any new types of paper to your chart. Encourage children to work with their family members to collect and bring in paper.

2 As the paper arrives, talk about its different colors, sizes, shapes, and textures. Set out paper plates or trays for sorting. Together, choose a general characteristic such as colored or white, and sort the paper into piles. Then try sorting it by other ways, such as size, shape, and pattern.

3 Make a graph on chart paper. Ask children to name different types of paper, and write the category names at the top of the chart. Then ask them to count how many samples of paper you have for each category. Make tally marks as they count, and invite children to read the graph. To expand on sorting skills, talk about whether one piece of paper can be in more than one category.

4 Ask children to help you select pieces of paper with distinctive colors or patterns. Provide scissors and let them cut each piece into two or three pieces. Encourage children to cut using a zigzag shape to create homemade puzzle pieces. Then put the pieces on separate trays and challenge children to find the matching pieces and fit them back together.

Observations

- Do children invent their own ways to use the paper?

Books

Try these books for more sorting and matching fun.
- *Caps for Sale* by Esphyr Slobodkina (HarperCollins)
- *Dots, Spots, Speckles, and Stripes* by Tana Hoban (Greenwillow Books)
- *A Pair of Socks* by Stuart J. Murphy (HarperCollins)

SPIN-OFFS

- Recycle! Find out what kinds of paper your local recycle center will accept and how they should be sorted. If possible, go on a field trip to bring the paper to the center.
- Ask children to brainstorm ways to use paper that can't be recycled. Write down their ideas, and then follow through on as many as you can.

Pattern Trains

All aboard to practice patterning.

Materials

- sheets of white paper (about 10″ x 22″)
- construction paper in various colors
- scissors ■ glue

In Advance

Cut construction paper of various colors into 3-inch squares. Make a simple "pattern train" from unified cubes or some of the paper squares. Start with a simple pattern, such as red, blue, red, blue. Wrap a sheet of paper around the train to make a "tunnel" that conceals the entire train.

Warm-Up

Gather children together, and show them your tunnel. Tell them there is a train inside, but it will only come out one car at a time. Pull the train out so children can see only the first square; ask them to identify the color. Then pull just enough to see the second square, and ask children to notice the color again. Continue this until the pattern is evident. Then ask children to begin predicting what color will come out next. Ask children how they know which color it will be. Talk about patterns and how they work.

Activity

1 Distribute the sheets of white paper to children, and then set out colored squares, keeping the colors separate. Invite children to make their own pattern trains.

2 Encourage children to plan out their patterns before you hand out the glue. If some children have trouble understanding the concept of pattern, you can assist them before they begin.

3 Now distribute the glue, and have children glue the squares, or "train cars," onto the paper. They may want to draw an engine and caboose on the ends of their trains.

4 Invite children to make "tunnels" for their pattern trains. Then they can play the guessing game with one another.

Remember

- Pattern can be a difficult concept to grasp for some children. Help them to discover patterns in things like clothing, wallpaper, and floor tile.

Observations

- Are there various levels of children's pattern making? Are children able to create more complicated patterns?

Books

Enjoy these books about trains.
- *Freight Train* by Donald Crews (Greenwillow Books)
- *Shortcut* by Donald Crews (Greenwillow Books)
- *Train Whistles* by Helen Roney Sattler (Lothrop, Lee & Shepard)

SPIN-OFFS

- All kinds of materials can be used for patterning. Try colored beads and string, for example, to make pattern necklaces.
- Take a "pattern walk" around your school or neighborhood. Encourage children to find the patterns around them—for example, on floors, sidewalks, walls, and fences. Make an experience chart of children's findings, and invite them to represent on paper the patterns they saw.

Make a Puzzle

Children explore a whole and its parts.

Materials

- white oaktag or posterboard (about 8″ x 11″)
- markers
- crayons
- safety scissors
- self-seal plastic bags or manila envelopes

Warm-Up

Gather children together and show them a puzzle from your classroom. Encourage them to talk about the kinds of puzzles they like to do. Ask children to describe their methods for doing puzzles. Do they try to find shapes that fit together? Do they try to imagine how the whole picture will look when the puzzle is finished? Now take a few pieces out of the puzzle and ask children how they think puzzles are made.

Activity

1 Distribute oaktag or posterboard to children, and encourage them to plan their pictures carefully. They might choose to draw their home, themselves, or a family pet. Encourage children to draw any scene they like, but remind them that drawing a colorful, detailed picture will make the puzzle pieces more distinguishable.

2 Provide markers and crayons, and remind children that their pictures will be turned into puzzles. See if they can guess how this will be done.

3 When children's pictures are complete, ask if they can figure out a way to make them into puzzles. Help children to cut their pictures into fairly large puzzle pieces of simple shapes.

4 Encourage each child to mix up his or her puzzle pieces and put them back together again. Then invite children to trade puzzles and try to put other children's pictures together. The puzzle pieces can be stored in plastic bags or envelopes to be used again and again.

Remember

- Some children may be reluctant to cut their pictures up. Allow them to inspect a simple classroom puzzle, and remind them that they will be putting the pictures back together again.

Observations

- Are children able to connect the concepts of the whole and its parts? Are they able to put their pictures back together?

Books

These books explore the concept of parts-to-whole.
- *The Patchwork Quilt* by Valery Flournoy (Dial)
- *Pelle's New Suit* by Elsa Beskow (Harper & Row)
- *Ten, Nine, Eight* by Molly Bang (Greenwillow Books)

SPIN-OFFS

- A fun way to explore parts-to-whole is by making a silly flip-book. Give each child a piece of drawing paper and ask them to draw a picture of themselves. Cut the pages into three even horizontal strips, leaving one edge intact for binding. Staple the book together, and invite children to "flip" the strips in different combinations to see some very funny pictures!

Mosaic Shape Placemats

Make snack time a chance to explore shapes.

Materials

- 2 sheets of 9″ x 12″ contact paper per child
- construction paper in a variety of colors
- scissors

In Advance

Cut construction paper into small circles, squares, triangles, rectangles, and any other shapes you choose.

Warm-Up

Read a book about shapes to the class. (You may want to choose one from the list below.) Then encourage children to find different shapes around the room. Now show them the colored cutout shapes, and encourage children to identify them. Invite children to match the paper shapes with the ones they've found in the room.

Activity

1 Help each child to peel the covering from one sheet of contact paper. Then set out colored shapes, and invite children to stick shapes onto the adhesive paper to create a design.

2 Encourage children to place shapes close together and try to fill up the whole space. Encourage them to notice which shapes fit flush together (squares, triangles) and which do not (circles). Encourage them to talk about their designs and the shapes they are using.

3 When designs are complete, help children to cover them with the second sheet of adhesive. To avoid bubbling, start by attaching one end and slowly working your way down, smoothing as you go. (Later, you can also prick bubbles with a pin.)

4 Trim edges if desired. Placemats can be used for snack time or lunchtime and can be cleaned with a sponge. Children can talk about their designs while they eat!

Remember

- Contact paper can be difficult to work with. Remind children to plan ahead — once a piece is put down, it cannot be picked back up without damage to the paper. Children may also need assistance in attaching the second sheet because bubbles and wrinkles can easily occur.

Observations

- As children choose pieces for their designs, do they identify them by shape? By color?

Books

Try this author's books on shapes and colors.
- *Circles, Triangles and Squares* by Tana Hoban (Macmillan)
- *Is It Red? Is It Yellow? Is It Blue?* by Tana Hoban (Greenwillow Books)
- *Shapes and Things* by Tana Hoban (Macmillan)

SPIN-OFFS

- Try making a "shape snack." For example, you might use round crackers and cut slices of American cheese into triangles. Serve the snack on children's placemats, and invite them to match their food shapes with the shapes in their designs.
- Shape designs may also be created by cutting up dry household sponges and making paint prints.